no place like home

no place

like home

B L O O M S B U R Y

LONDON • NEW DELHI • NEW YORK • SYDNEY

introduction jonathan freedland

Judah Passow says that his photographs are "intended to serve as a visual conversation." He's picked the right word. For if there is a singularly Jewish art form, conversation might be it. Some of the most evocative images in this collection are of still moments of talk: a couple negotiating over the frozen food section in Scotland's only kosher deli; another couple, this time ultra-orthodox, stealing a word through the *mechitzah*, the religiously-mandated partition designed to separate women from the yearning gaze of men; two old friends who need only a shrug to speak for them. Jews cherish their status as the people of the book – how many brides, moments before their wedding day, have a book open on their lap, like the Manchester bride shown here? – but the way Jews study that holy book is through talk. Passow lets us watch the process unfold: two *yeshiva* students, poring over a page of Talmud, whose essence they will discover through argument and discussion.

So if these photographs are a conversation, what are they telling us about the small community of Jews in the United Kingdom, whose number is estimated at not much more than 250,000? The first clear message might come as a surprise, not least to British Jews themselves. For Passow's Jews are not the embarrassed, hesitant people of Anglo-Jewish mythology: quietists with their heads down, striving not to make trouble, striving, if truth be told, not to be noticed at all.

Instead these Jews are out and proud, happy to drive around in a car lit up by the instruction "Eat Kosher Always" or to be tattooed – a practice, incidentally, at odds with Jewish stricture – in the ancient characters of Hebrew. The voices of Jews of a certain generation still dip when they say the J-word in a public place, as if wary of being caught, yet many of the Jews seen by Passow are standing tall and proud, the cautious whisper of the past replaced by a confident, even raucous declaration of Jewishness for all to hear.

The two City workers, sheltering under an umbrella as they take lunch in a *sukkah* – the temporary dwelling used for eight days in early autumn to remind Jews of the years of desert wandering – are doing something their grandfathers would not have believed possible. Sixty or seventy years ago, it would have seemed like a choice: either you get a job in the City or you maintain the Jewish traditions of old. Today's Jews refuse that binary division of either/or. They insist on the right to do and to be both. Walk among the verdant and enduringly English lawns of Kensington Park or blow the shofar, the ram's horn that trumpets in the Sabbath and the New Year? The child photographed by Passow has her own answer: why not do both?

Indeed, hybridity – this fusing of apparent contradictions – is a theme that runs unspoken through these images just as it runs through the Jewish community itself. It goes beyond the obvious fusion of ancient and modern, the orthodox woman

4

carrying a bag with a Marilyn Monroe print, the *yeshiva* boy checking his mobile phone. For the Jews on show here wear different identities, multiple allegiances, without apparent tension. They are visibly patriotic, proud of the land of their birth and citizenship. That's evident in the Union flag, glimpsed more than once, including on the plastic bowler hat worn by a volunteer at a care home in London's East End (a century ago, the very heart of British Jewish life). Evident too in the veterans bearing their medals, and wearing real bowlers this time, as they march in the annual parade of the Association of Jewish Ex-Servicemen. But the keen eye will also see it in Passow's image of two men in the synagogue for a morning service, watching over them, engraved permanently on a plaque, the "Prayer for the Royal Family". That invocation can be heard in almost all British synagogues on a sabbath morning: I heard it so often in my childhood, I can write it down now from memory: "May the Supreme King of Kings in His mercy preserve the Queen in life, guard her and deliver her from all trouble and sorrow..."

As a boy, I thought that was normal, just as I thought guests at every wedding in Britain – Christian, Jewish or none of the above – stood up to sing the national anthem. It was only as an adult that I discovered that these days it is Jews alone who perform this ritual of grateful loyalty to the Crown and, indirectly, to the country that took them in. The patriotic habit extends north of the border: witness the tiny Jewish community of Scotland, with its tartan, bagpipes and Burns Nights.

Those Jews are proud to be Scottish or British or English: the Man Booker Prize-winning novelist Howard Jacobson, the unrivalled laureate of Jewish life in this country, resists being labelled "the British Philip Roth" preferring to be regarded as "the Jewish Jane Austen". But at the same time Britain's Jews are inseparably associated with Israel, to an extent that will disappoint those who, for disparate reasons, like to suggest that Jews and the Jewish state are utterly distinct entities. The Israeli flag turns up frequently in these pictures, there in the background, often alongside the Union flag, its presence seemingly unremarkable, even natural. That fits with the 2010 survey by the Jewish Policy Research think tank which found a tight connection between the Jewish community and the Jewish country, with more than nine in ten British Jews having visited Israel. The simple truth is that British Jews remain bound up with Israel, in a way that distinguishes them even from other Jewish communities around the globe. To quote Jacobson again, "In Israel, Jews see a version of themselves." For proof, look no further than that footballer's tattoo, etched into the back of his neck. What word is spelled out in those Hebrew characters but Israel?

Yet the Anglo-Jewish relationship with the country is not straightforward. Mixed with the pride and love can be anguish, especially at times of conflict. It discomforts British Jews to know few of their neighbours still see Israel as the heroic David of the pre-1967 years, that for many it is now an overmighty Goliath. Privately, around the Friday night dinner table, they

might agree with some of that critique, but publicly they are reluctant to voice it, lest they give succour to those they suspect don't much like Israel because they don't much like Jews. These ambivalences are too complex to capture in a single image, yet Passow comes close. His image of a Jewish member of the Palestine Solidarity Campaign, draped in a *keffiyeh*, is a reminder that even the hardcore anti-Zionist Jew remains bound up with Israel, if only in opposing it. Indeed, there are some British Jews whose sole Jewish association is anti-Zionism. The whole business is maddeningly complex.

This encompassing of contradiction is not confined to multiple affiliations: the Glasgow Jew who is proudly Scottish, Jewish, British and wrapped up with Israel all at the same time. It also straddles security and insecurity. I suspect outsiders will pause at Passow's image from a meeting of the Board of Deputies of British Jews. It reveals two police officers, both holding automatic weapons. Such a sight is rare outside airports or Downing Street, yet for British Jews it has become dully familiar. Almost every Jewish meeting, every Jewish school, every synagogue service, will have a security presence on the door. Jews no longer notice it. But it suggests that the police force have concluded that British Jews, left unprotected, are not safe.

Yet this apprehension co-exists alongside the new, extrovert Jewishness. Both are on show in that photograph of the Board

of Deputies: near the armed police is the blurred figure of a man wearing the traditional *kippa* or skullcap. This is one of the curious facts of today's Anglo-Jewry. Anxiety and confidence live together. The communal press is obsessed with antisemitism, yet British Jews live more vibrantly than perhaps at any other time in their history, boasting world class cultural institutions such as Jewish Book Week and the pioneering Limmud, a kind of Edinburgh Festival of Jewish life that is also captured by Passow. Is the glass half full or half empty? Perhaps there are two glasses, one next to the other.

Something else characterizes the community of today, a feature that, even if it was also true of the past, was much less readily acknowledged. It is that Britain's Jews – despite their meagre numbers – are plural. There are many forms of Jewish life, including religious life, on these islands, even if that is not the outward face Jews present to their fellow Britons. The casual Radio 4 listener, for example, would assume that British Jews all defer to the Chief Rabbi they hear on *Thought for the Day*, the way Catholics follow the Pope. In fact the Chief Rabbi is the spiritual leader of but one small section of the community: the 62 synagogues affiliated to the United Synagogue, all of them in London. Passow shows there are many more colours in the Anglo-Jewish rainbow, visible in the several female rabbis he photographs. There are Reform, Liberal and Masorti Jews, as well as lesbian and gay congregations.

Yet one group stands out: the ultra-orthodox Jews of Gateshead, Manchester and Stamford Hill. Is that because they are so photogenic – the image of, say, the catering manager, deferential and inquiring as she poses her question to the Rabbi, as eternal as if it had come from the pre-Shoah reportage of Roman Vishniac, if not from Anatevka, the fictional shtetl of *Fiddler on the Roof*? Or is it a matter of statistical reality, since the haredim are Anglo-Jewry's fastest growing community? A former Chief Rabbi used to advise those planning the Jewish future to focus on the ultra-orthodox, prophesying that they would eventually inherit the keys of Anglo-Jewry's lead institutions, for they would become the majority. So Passow is right to pay attention.

There is too, conveyed subtly, a story of decline in these pictures. For Jews are in retreat from the four corners of the British Isles and concentrating ever more in one city, London. There were once thriving Jewish communities in Leicester, Cardiff and Belfast, Liverpool, Birmingham and Glasgow. Passow catches a last glimpse of what remains, but they are disappearing before our eyes.

Yet the photographer does not see Jews in isolation. He also notices their interaction with their neighbours. Staring out at us is the face of a Loyalist Protestant in East Belfast, an Israeli flag fluttering behind him – a kind of proxy Jewish solidarity, originating in a bizarre sectarianism which sees Northern Ireland's Catholic nationalists waving the flag of Palestine. We see too two boys, one Jewish, the other Muslim, at play at King David School, Birmingham. The local Jewish community is too small to fill a school by itself, so its doors are open, making King David an unlikely hub of integration. (Moazzam Begg, the British citizen held for three years at Guantanamo Bay as a suspected terrorist – charges Begg denies – was a King David boy.) We see too the synagogue that serves as a drop-in centre for asylum seekers, a Jewish doctor offering advice and a haggard, sympathetic face to an African refugee. In other words, Jews have had an impact on Britain in ways you might never have imagined.

And we see that, for all the emphasis on differences of custom and faith, Jews are not that different from everyone else. The young woman flirting with the chap outside Kosher Kingdom; the kids waiting for their dinner; the *Bar Mitzvah* boy waving, relieved and proud, to his mum; the female victim of domestic violence, her head hanging low in despair; the old lady touching the pregnant belly of a young helper, hoping to feel the heartbeat of the next generation – these are universal images. Passow could have found something like them anywhere in the world. It is British Jewry's good fortune that he found them here. In the process he has produced what should be an enduring record of a small, varied, vigorous community that has made on these islands a place it calls home.

home page judah passow

Every story I've ever shot has always started out the same way – as an idea. This one was no exception.

My father devoted his entire professional life to exploring questions of Jewish identity. A rabbi and a historian, he was fascinated by Judaism's complexity, its subtle but profound impact on civilisation, and by the intellectual games it seduces you into playing. More than anything else, though, my father loved the fact that Judaism was, at its core, essentially an idea, and that everything that flowed from that big idea is just someone's interpretation. Some of those interpretations are more interesting and perhaps better informed than others, but no one *really* knows what's going on. As far as he was concerned, everyone is just guessing. He was fond of quoting Albert Einstein: "You know what makes God laugh? Listening to people making plans."

When he died in the autumn of 2008, I found myself toying with the thought of producing a set of photographs that would honour his values, his passion, and his vision.

This, then, is a story about identity. About belonging. These photographs are intended to serve as a visual conversation with Britain's contemporary Jewish community. They explore one of its defining characteristics – the ability to simultaneously acknowledge the traditional past, live in the creative present, and build for the future. They are about what drives us, what defines us, and what we do that gives our life meaning as Jews living in Britain at the start of the new century.

The people I photographed allowed me to share with them a remarkable range of very personal moments, a privilege that informs the work with a special intimacy. The largely unrestricted access to cultural and religious institutions, community organisations and social groups all around the country enabled me to take photographs which examine those shared values that create an astonishing sense of belonging – values expressed through work, study, charity, social action, worship, and the marking of traditional milestones in Jewish life. These images are a window on to the many identities that make up our community.

Wherever I went throughout the year-and-a-half long project, I found that certain core themes always presented themselves, serving as a kind of cultural glue holding that particular community together – the observance of Jewish holidays, the centrality of family life, and the importance of humour, education, compassion and personal reflection as forces shaping both character and identity.

What I found so revealing was how Britain's Jewish community has been able to build a safe and comfortable home for itself by continually examining and adapting its complex religious and cultural heritage to the real world demands of the larger society in which it lives. This capacity for self-questioning and re-invention is the source of the Jewish community's vitality and achievement, and the reason for its survival.

Two of the most significant developments resulting from this capacity for re-invention are, interestingly enough, both about

the role the synagogue plays in contemporary Jewish society. The ordination of women rabbis and their growing visibility on the pulpits of congregations around the country has become a mainstream fact of our community's life. While other faiths either still debate the gender issue or reject it out of hand, we have responded with confidence to demands from within our own ranks for equality and relevance.

Our synagogues have moved dramatically from being merely a *Beit Tefilla* – a house of prayer – to a true *Beit Knesset* – a meeting house, where the full, rich spectrum of our cultural heritage is explored by opening their doors to study groups, political debates, theatre productions and film screenings, youth groups, elderly care, social action programs and much more. Our houses of prayer have become homes to our community's creativity and imagination.

The community I photographed is full of energy, purpose, and above all – pride. This new century marks the point at which the emotional baggage of the immigrant generation has finally been left behind. Britain's Jewish population is now tightly woven into the national fabric.

In taking these photographs, it has become very clear to me that the torch of our identity as Jews is being passed to a new generation – what Israeli novelist David Grossman describes as the transition from The People of The Book to The People of Facebook. Some of us may have difficulty recognising the kind of Judaism our children find meaningful

and fulfilling, but then so did our immigrant grandparents with their children, and I suspect many of our parents did with us. We are constantly evolving. That is our strength.

What we are witnessing is not that clichéd mantra about the slow death of this country's Jewish community, but rather the confident assertion of its unique and vital place in 21st century British life.

Judah Passow
London 2013

9

no place like home

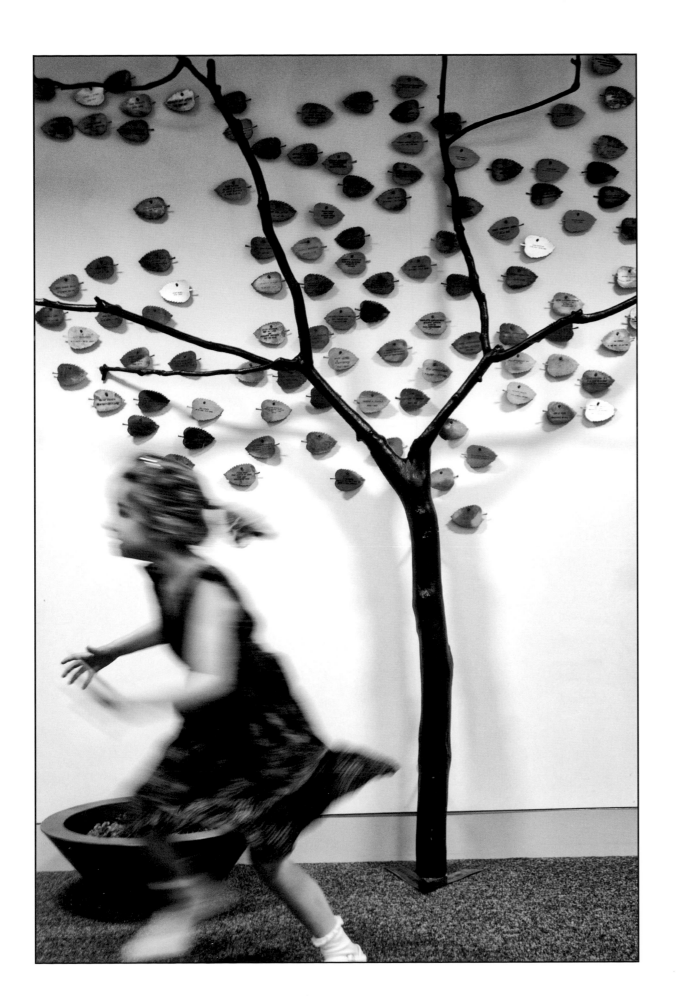

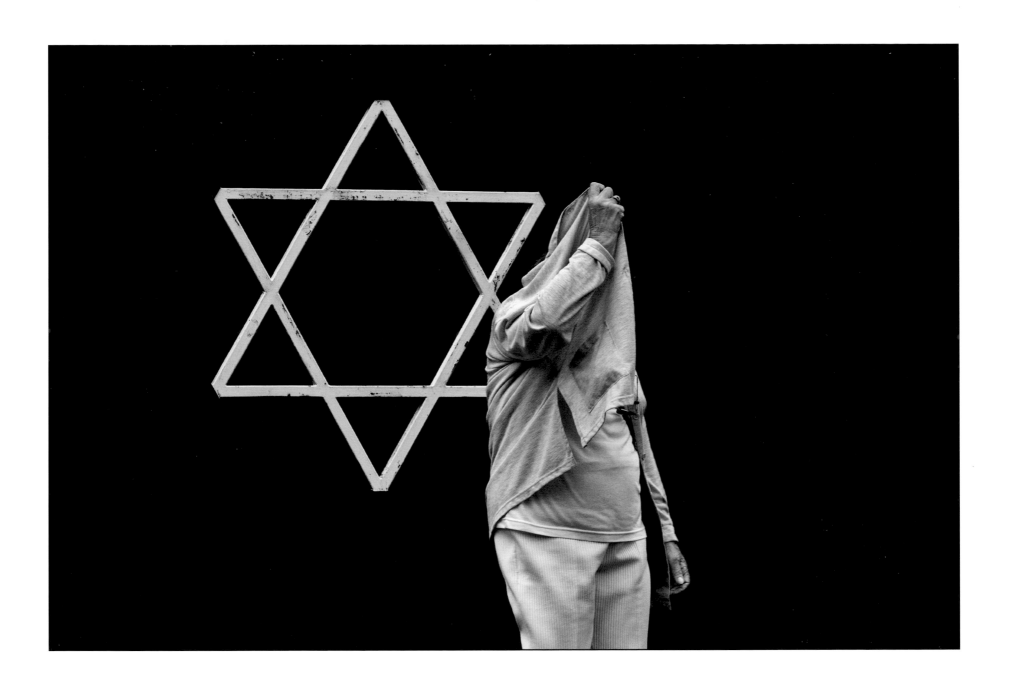

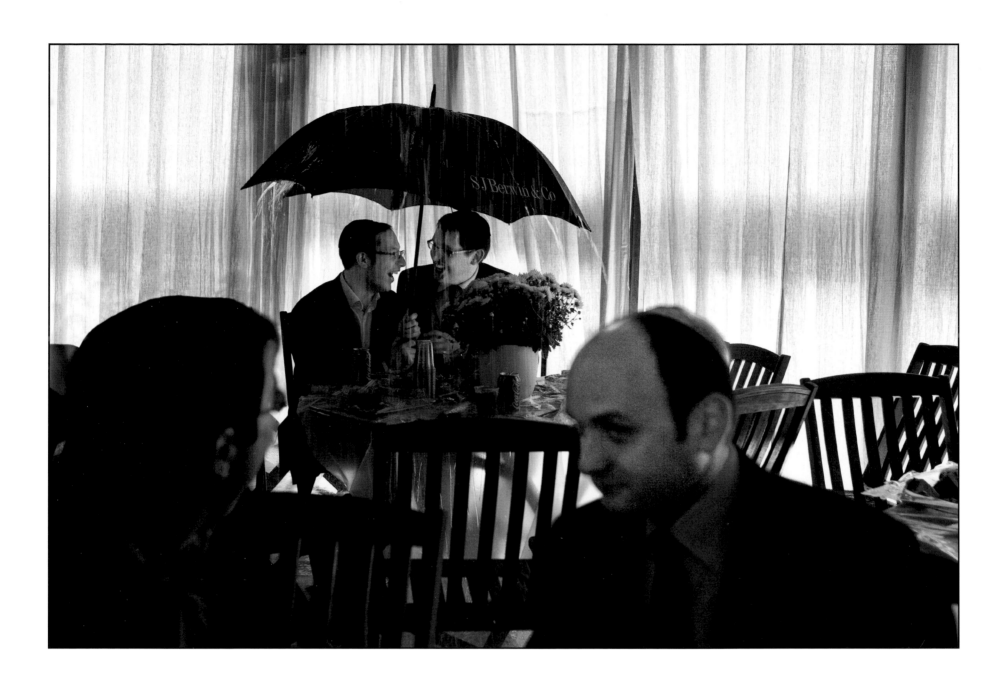

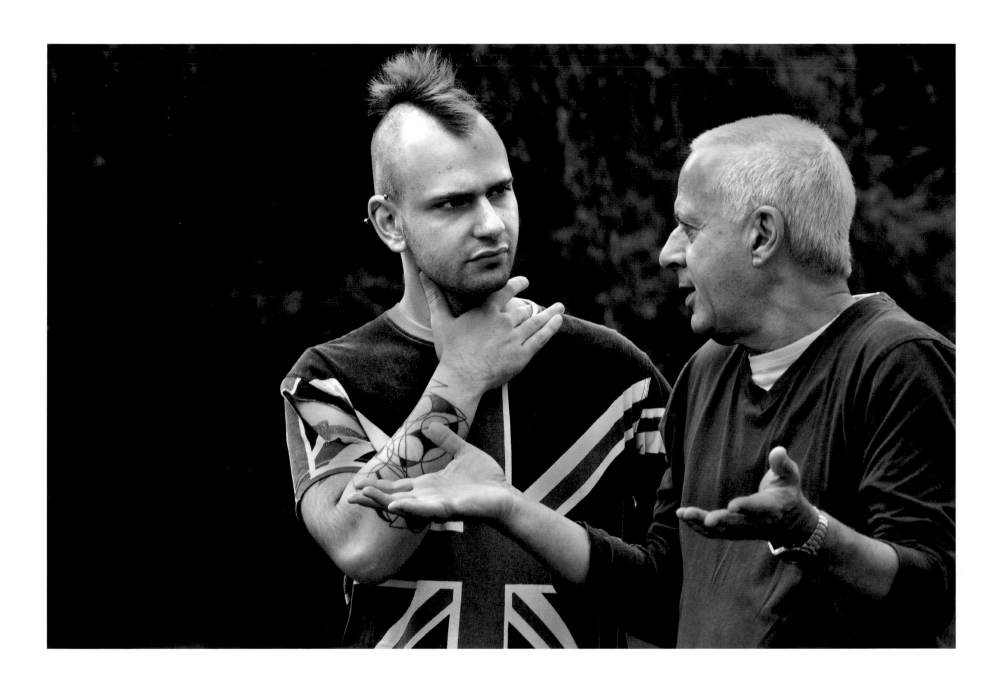

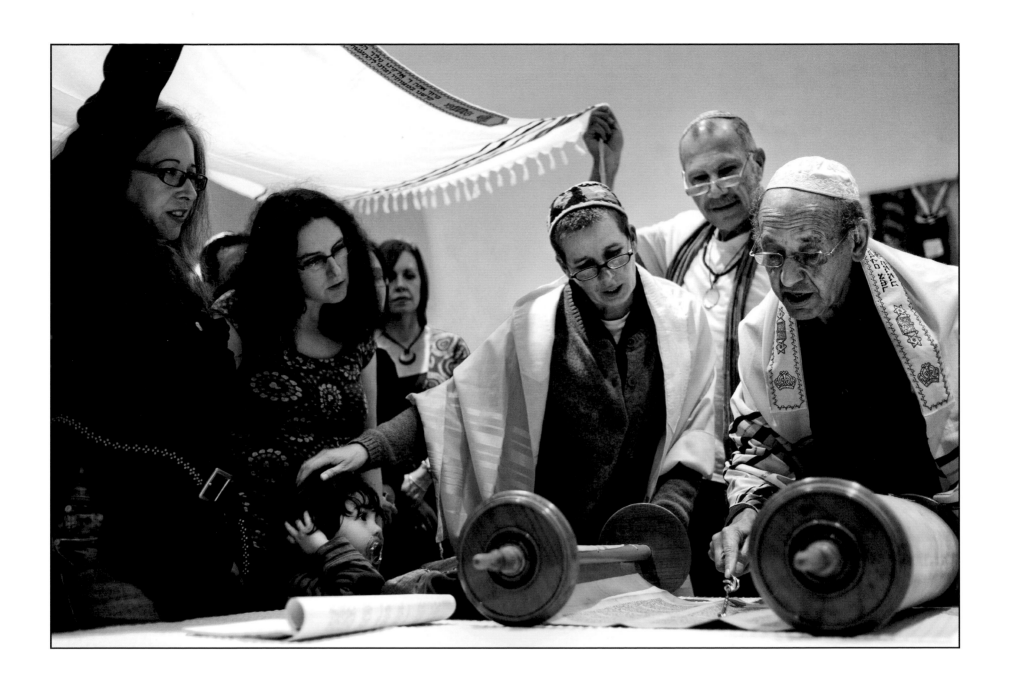

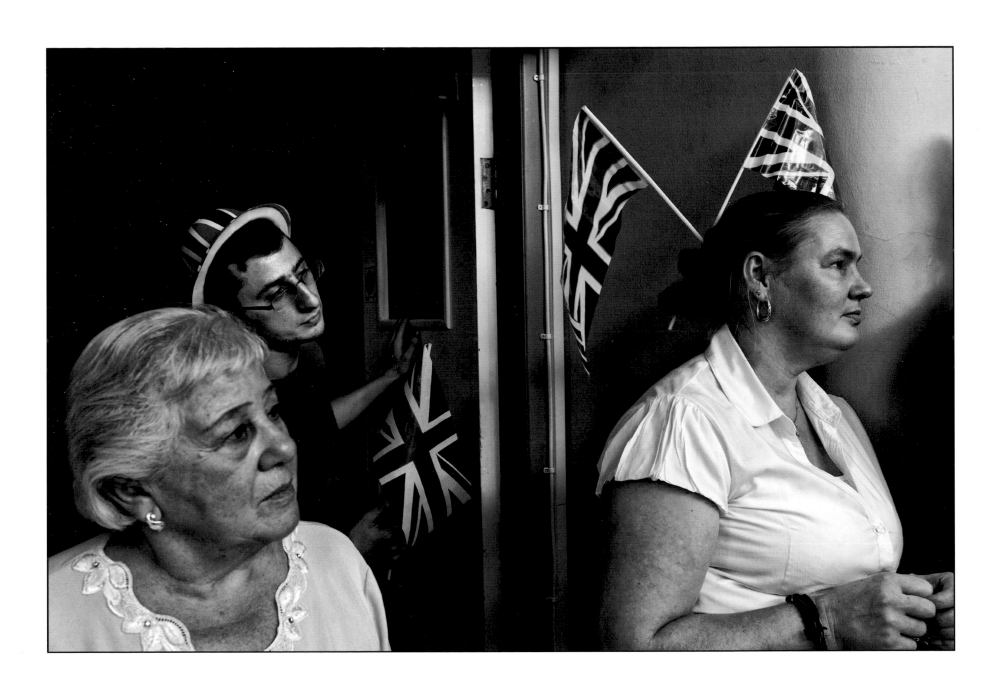

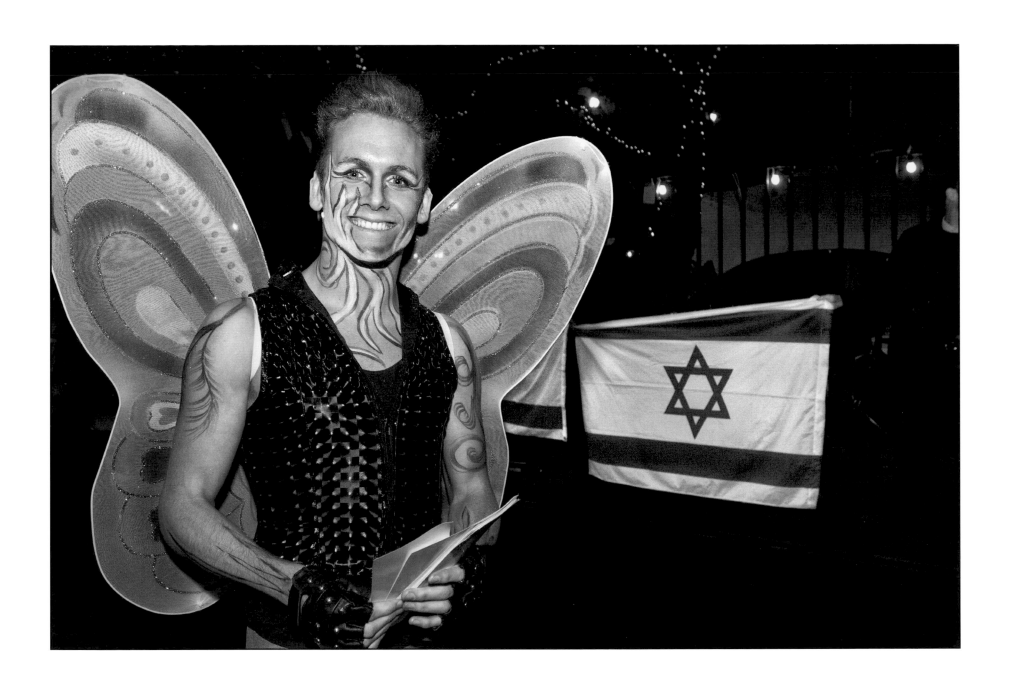

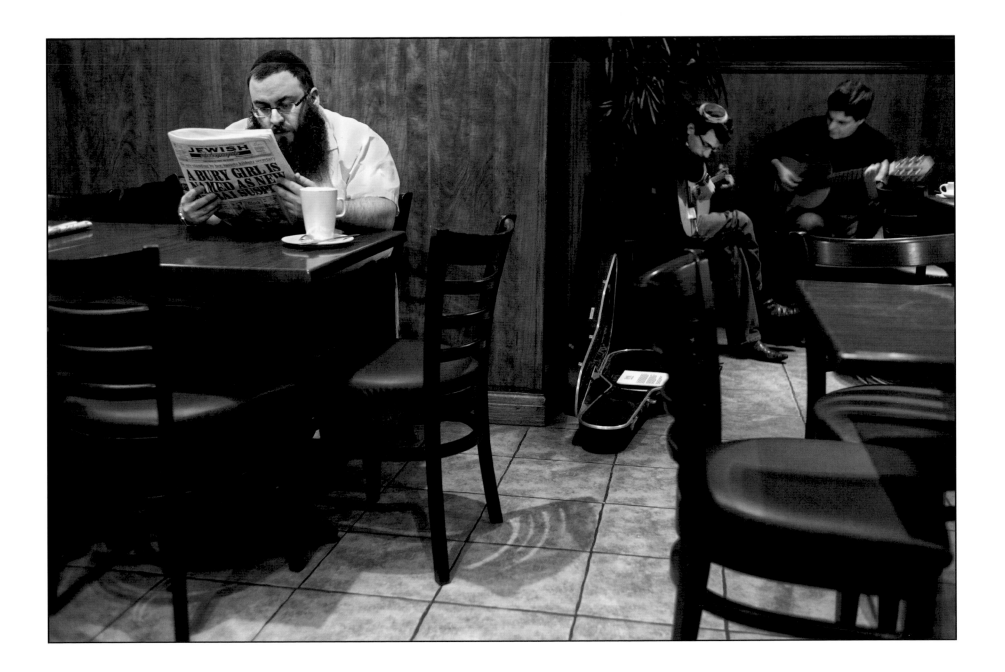

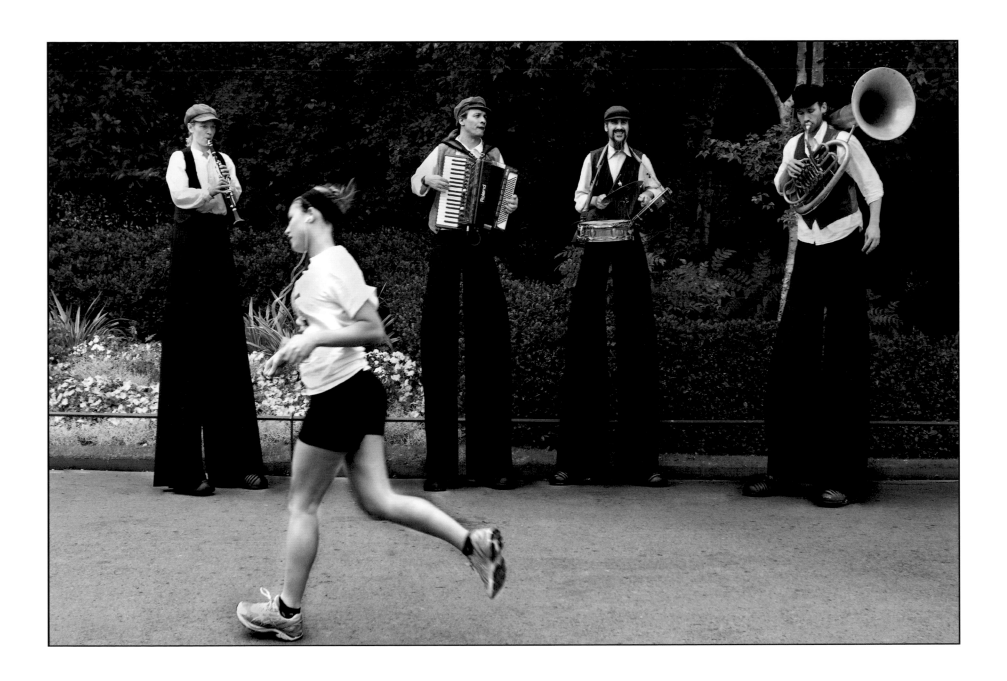

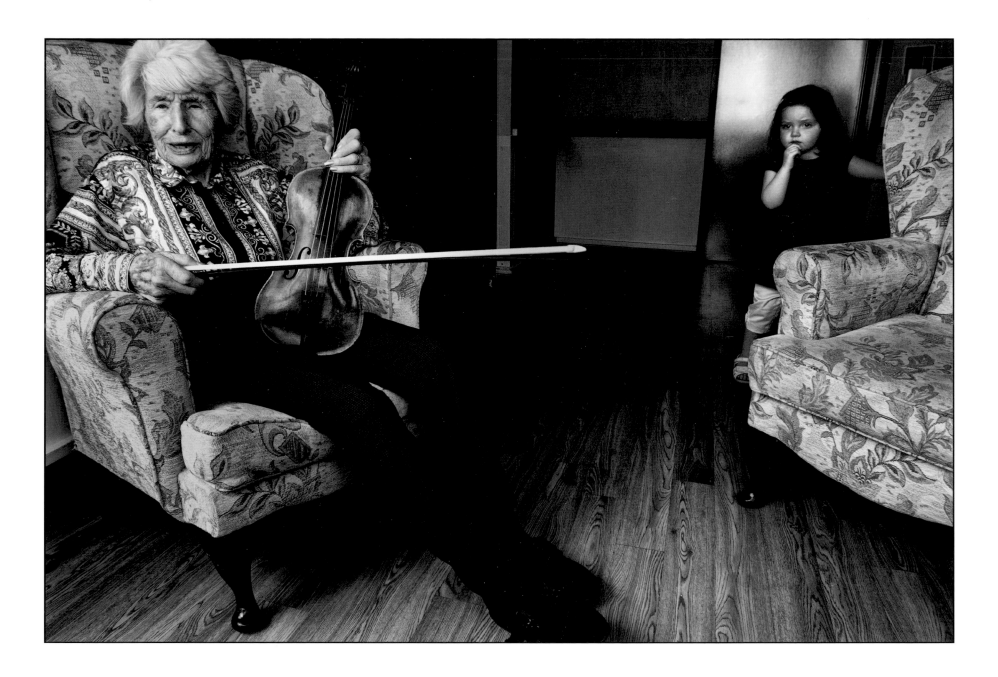

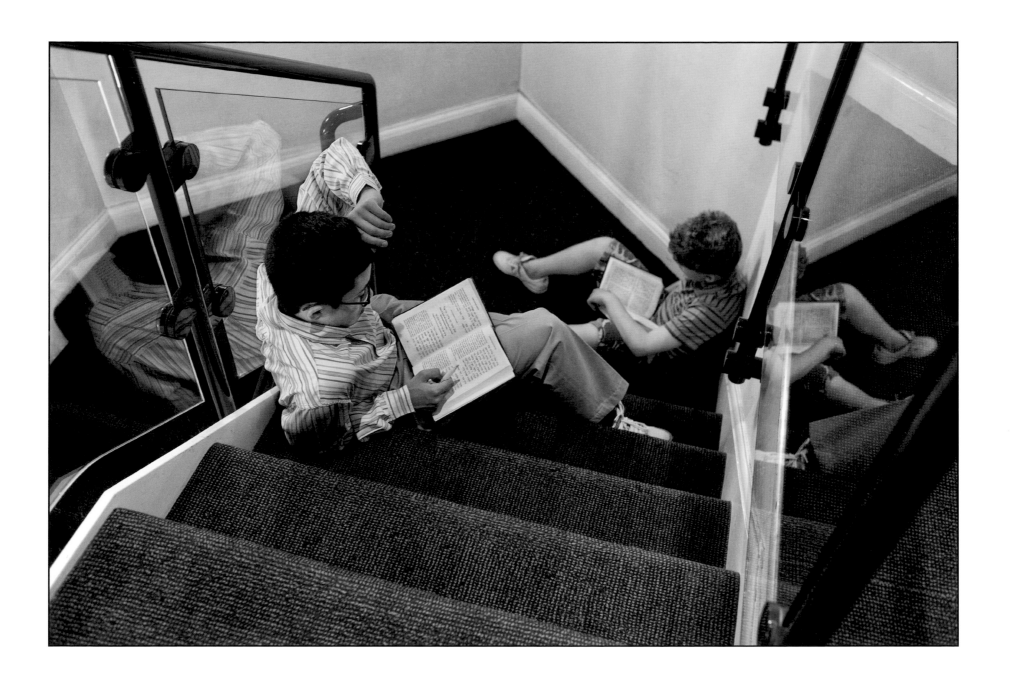

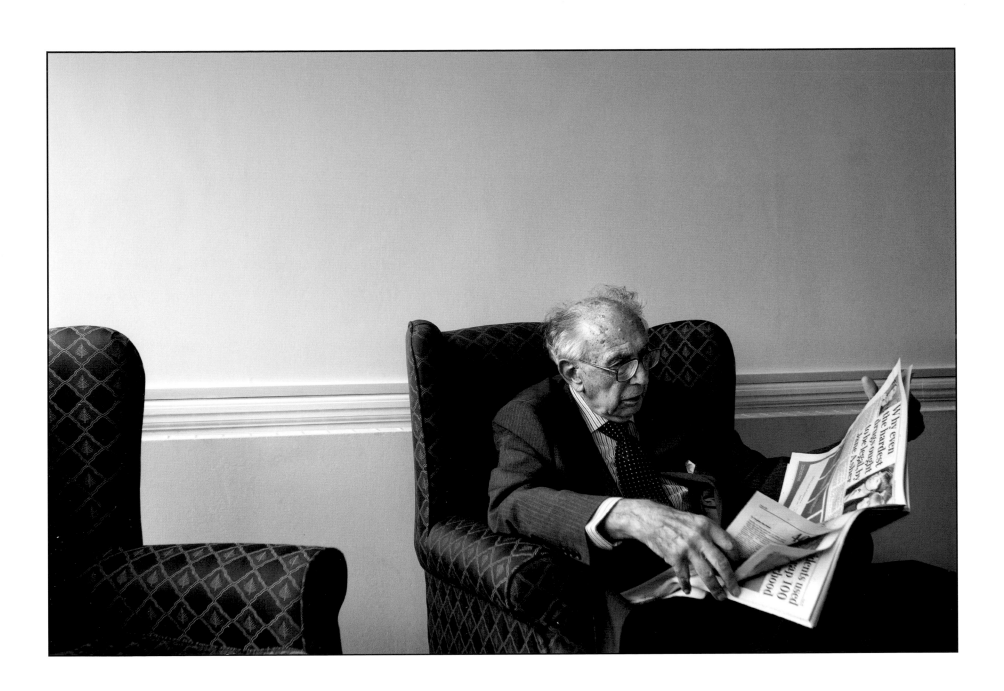

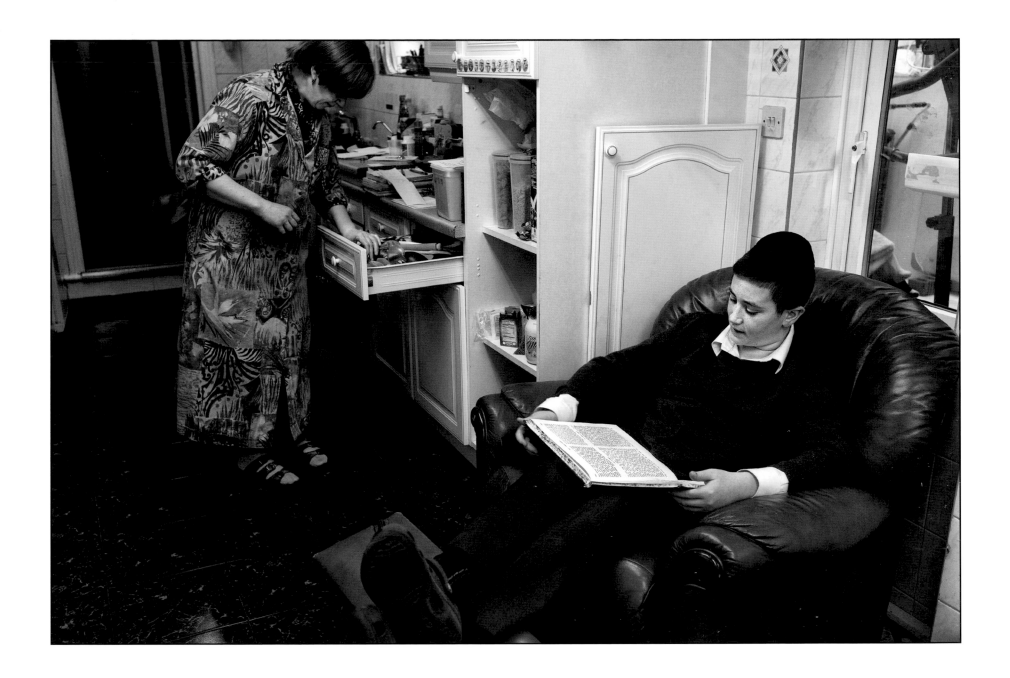

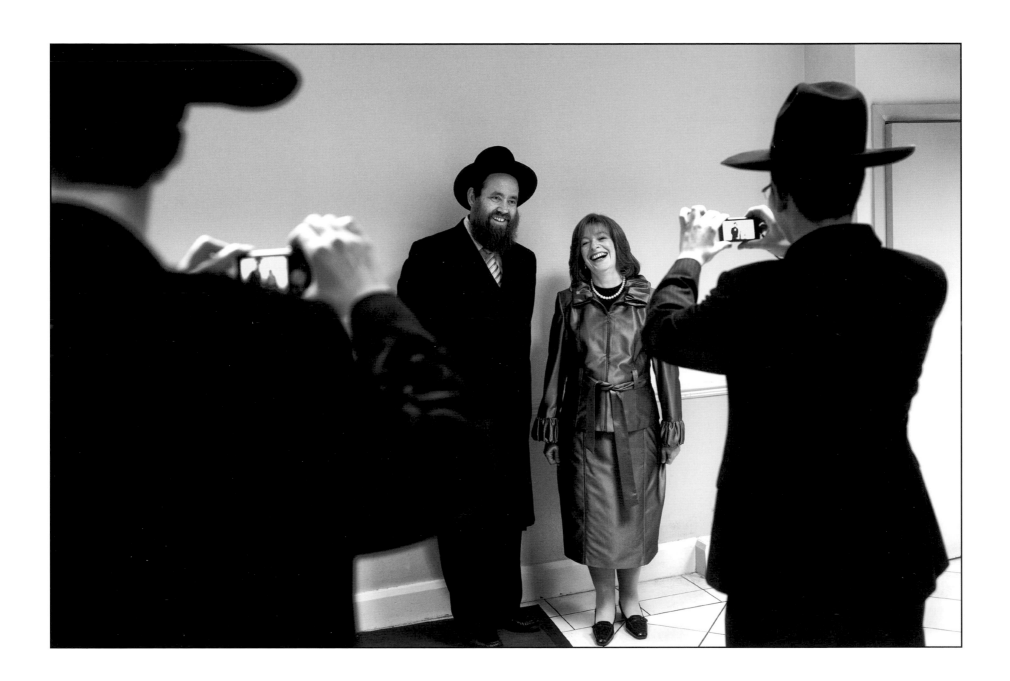

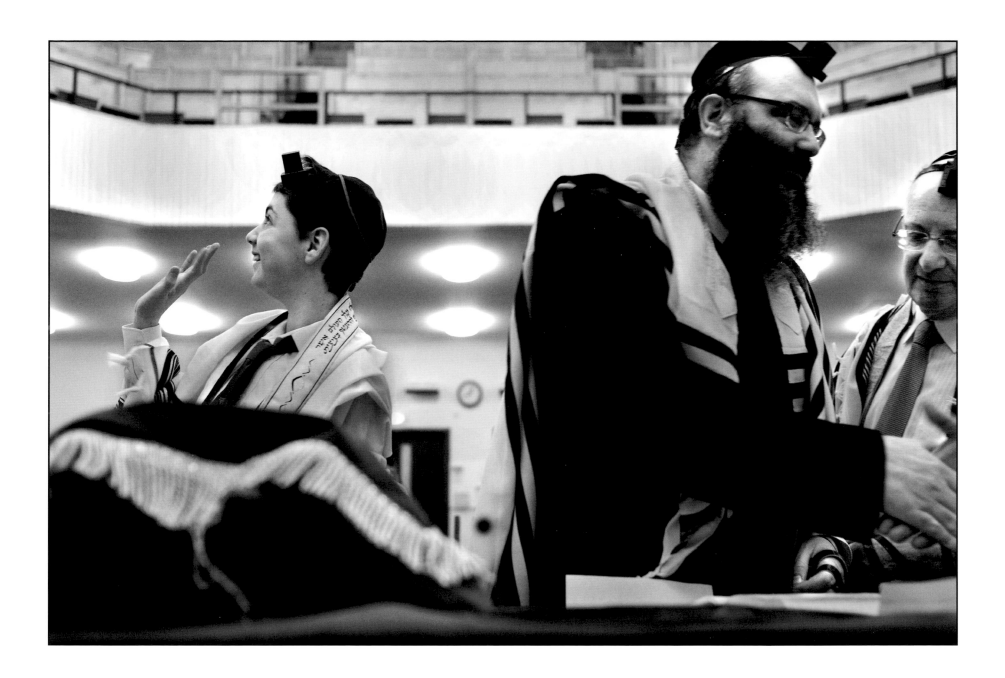

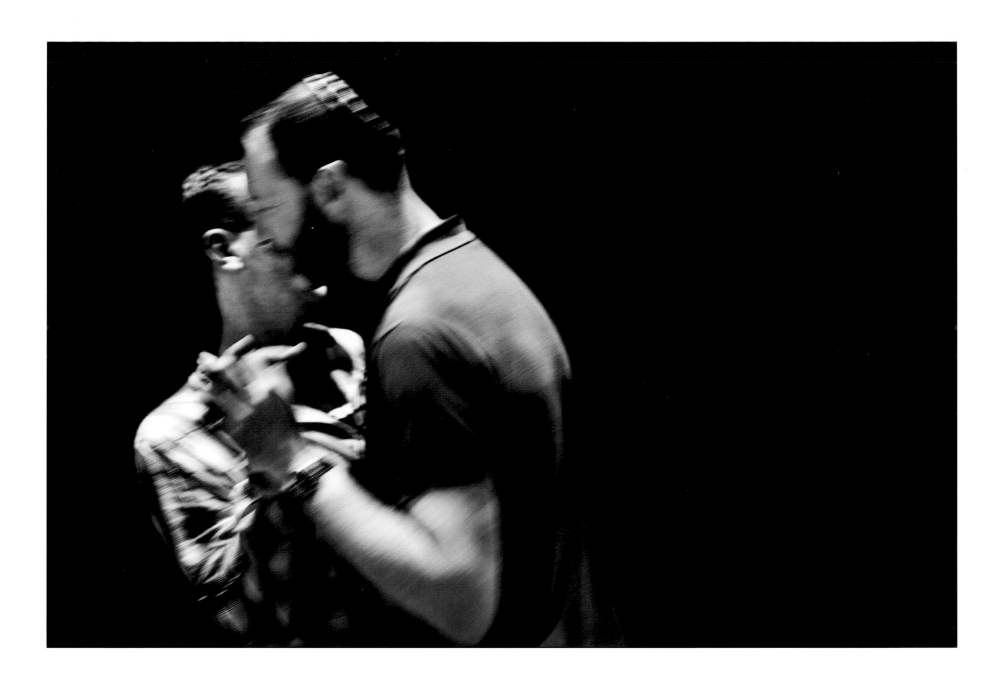

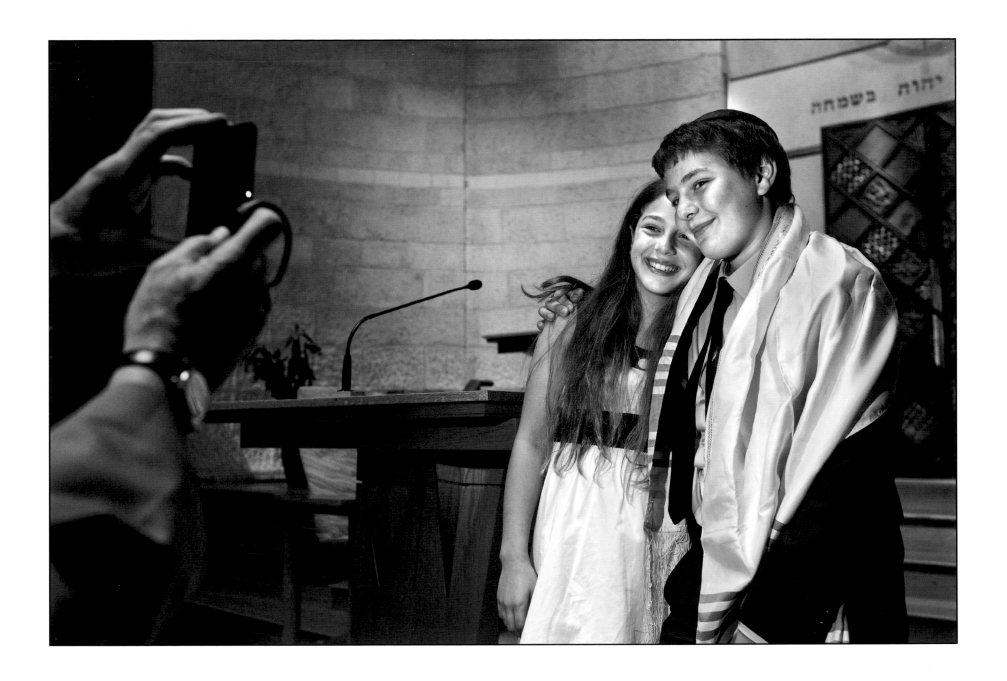

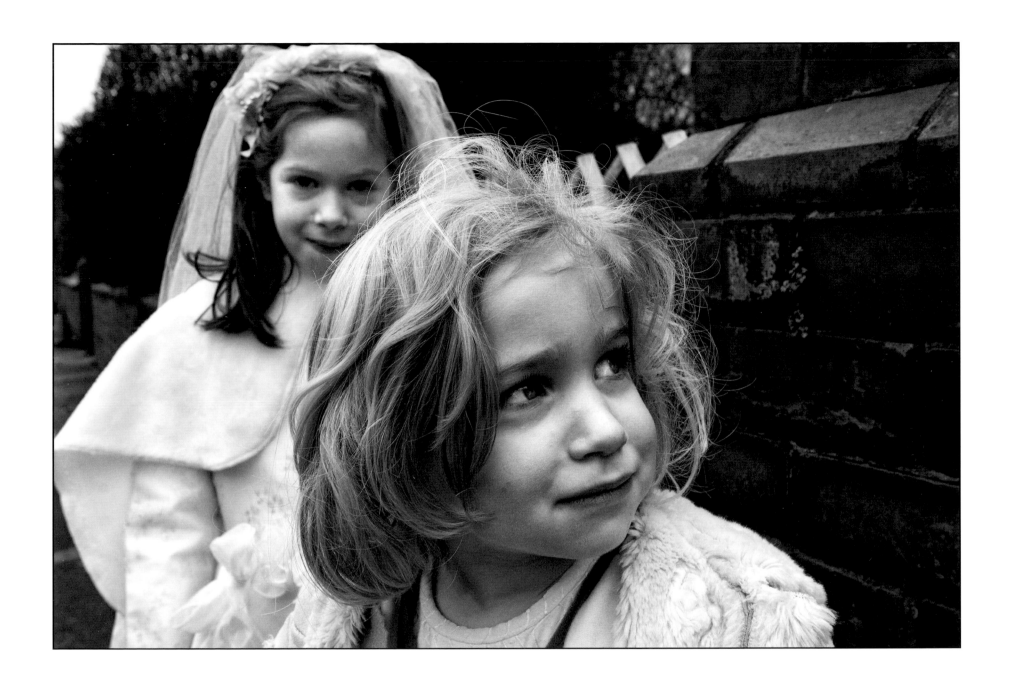

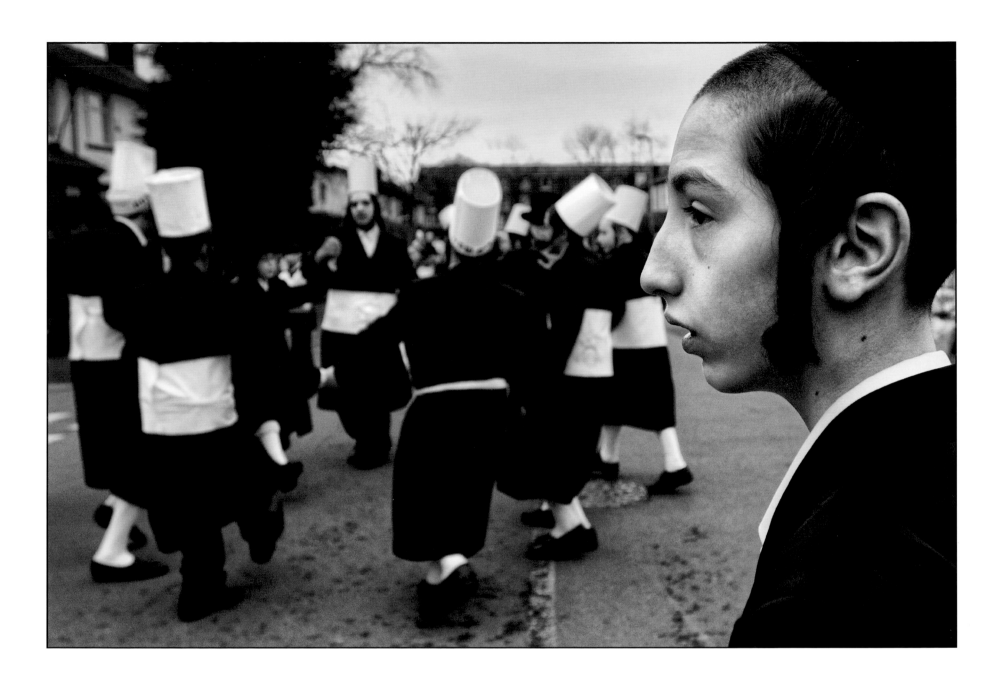

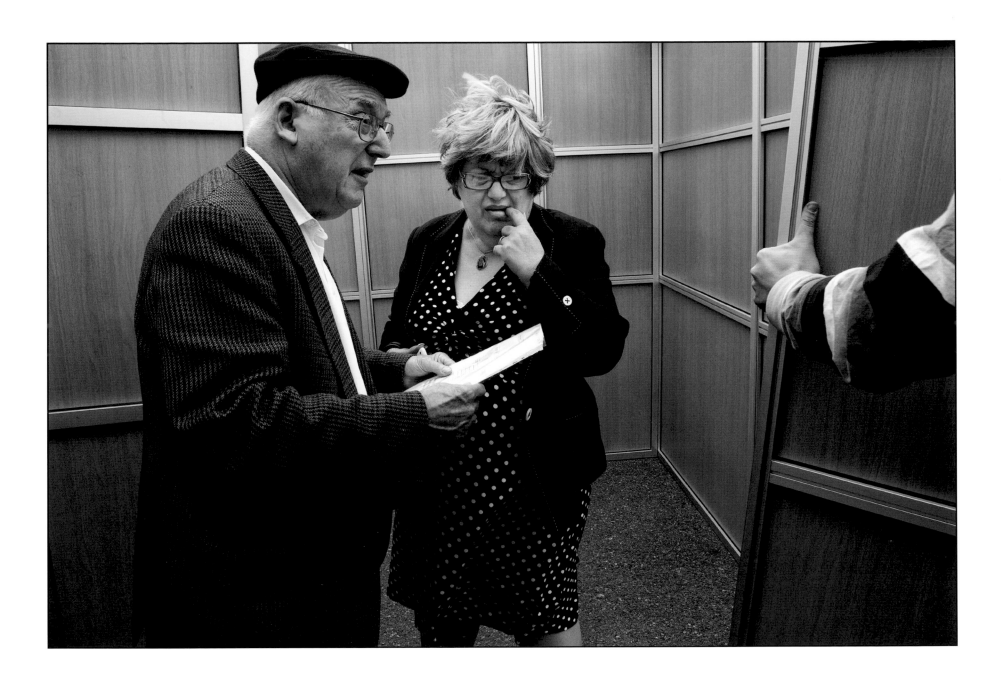

LONDON 2010

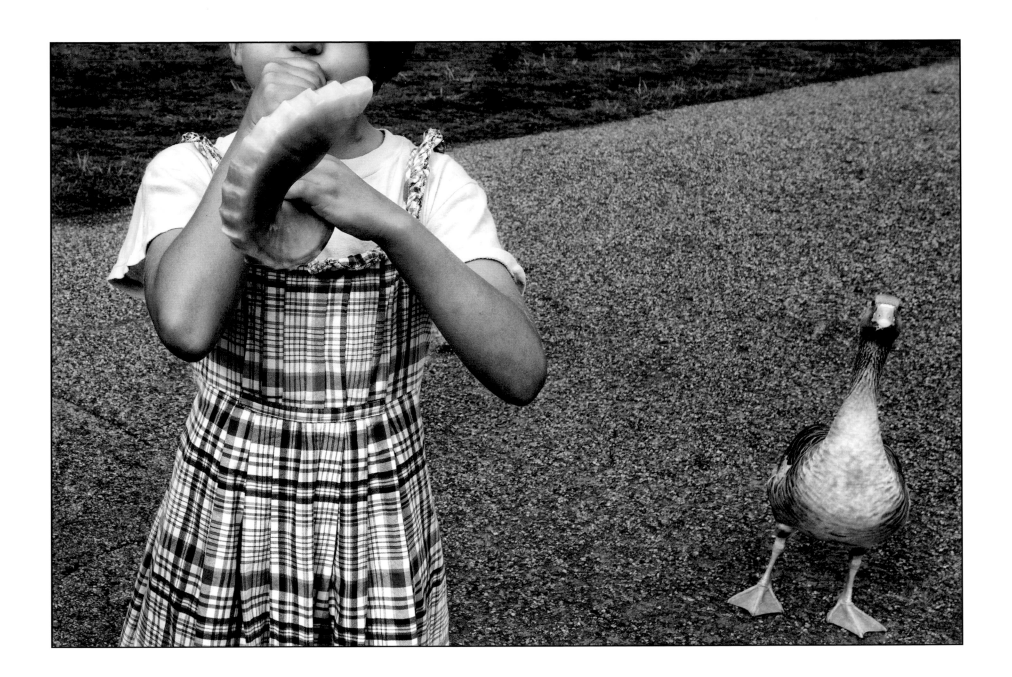

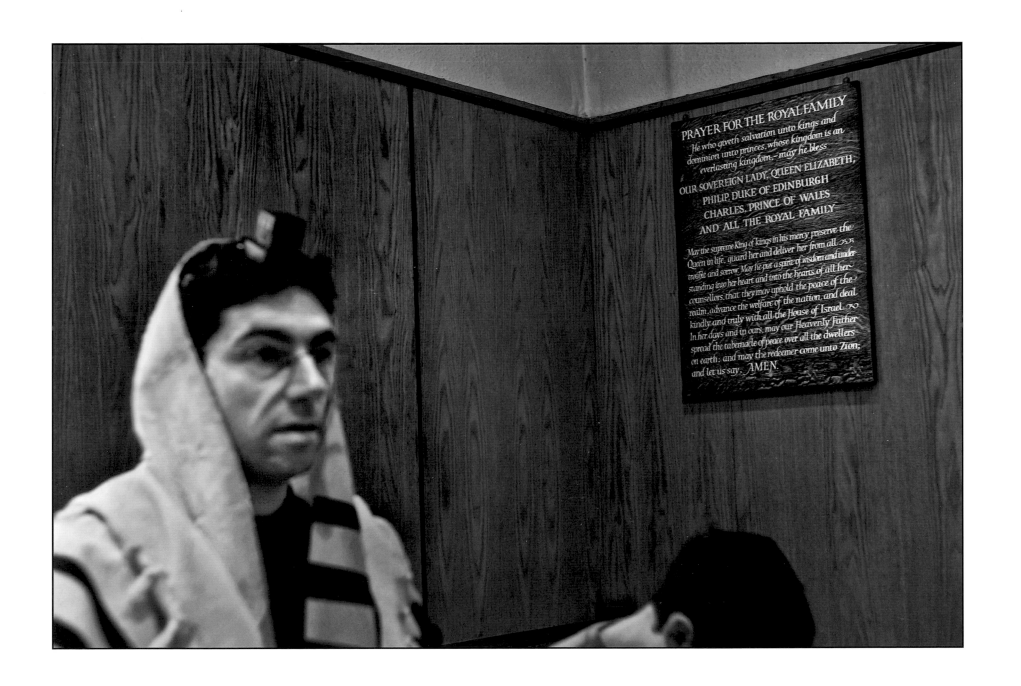

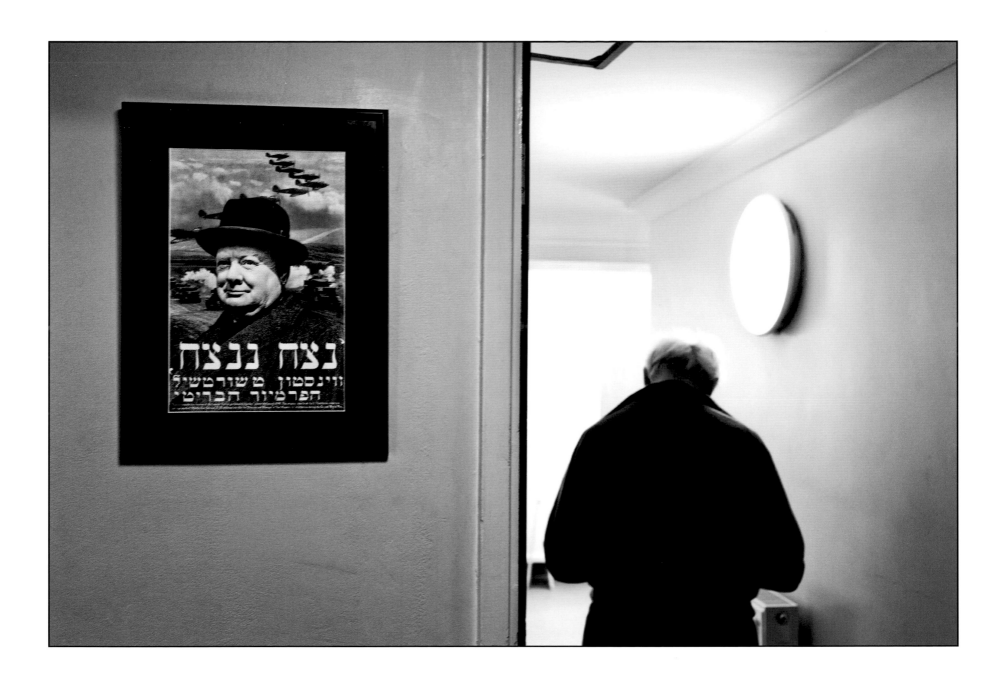

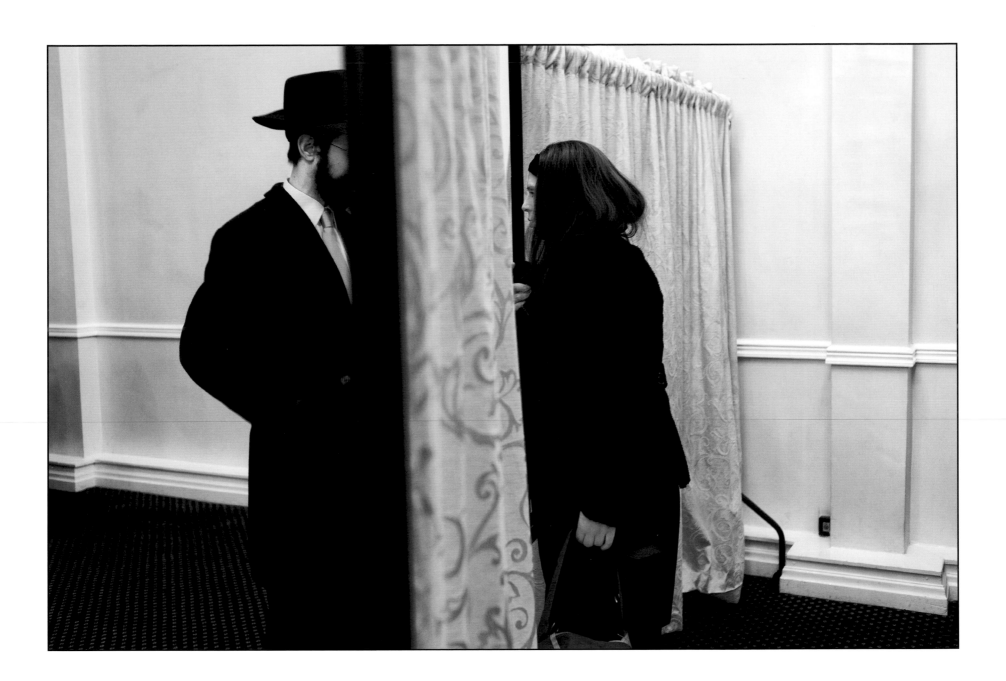

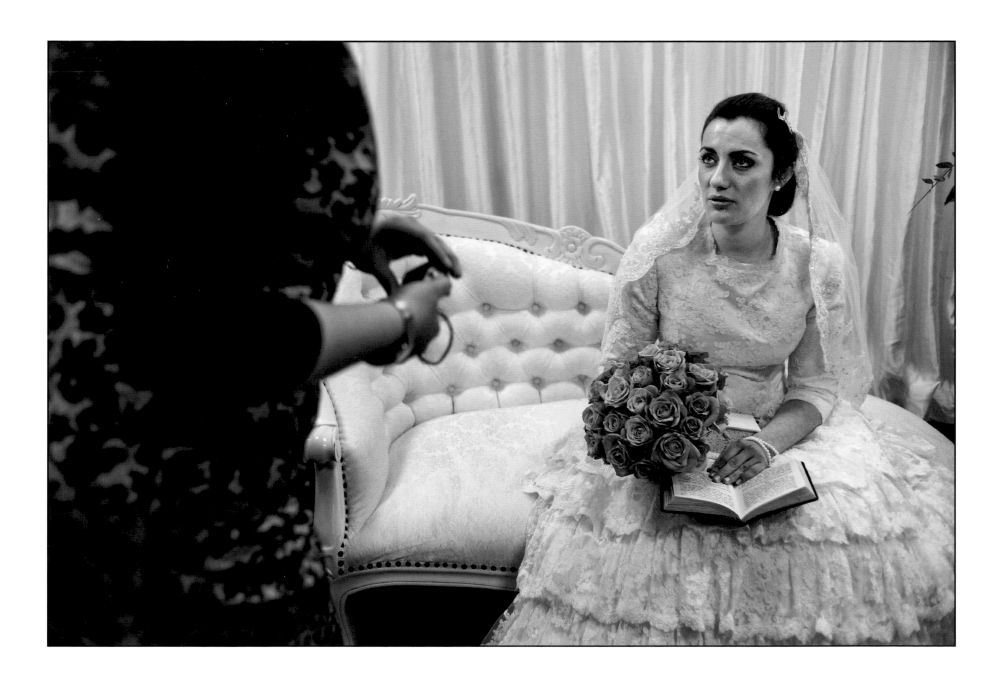

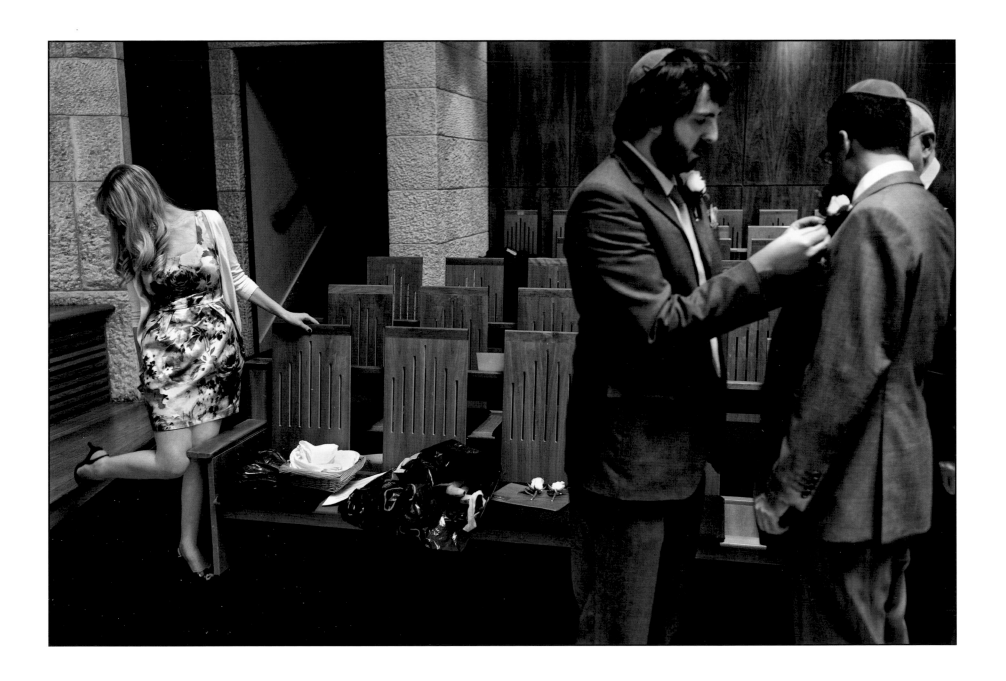

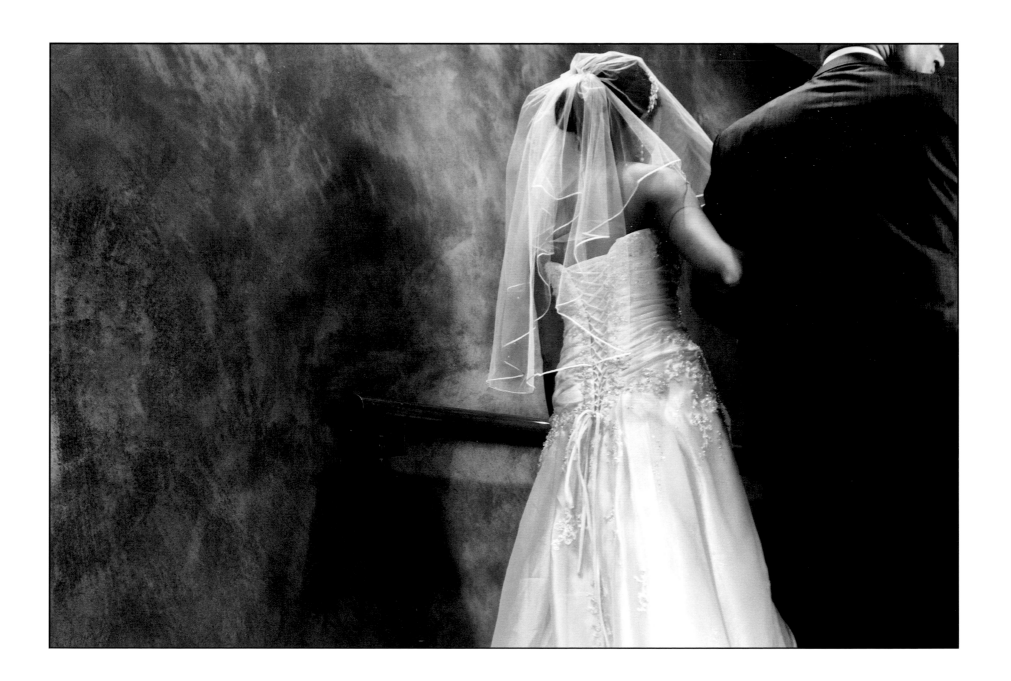

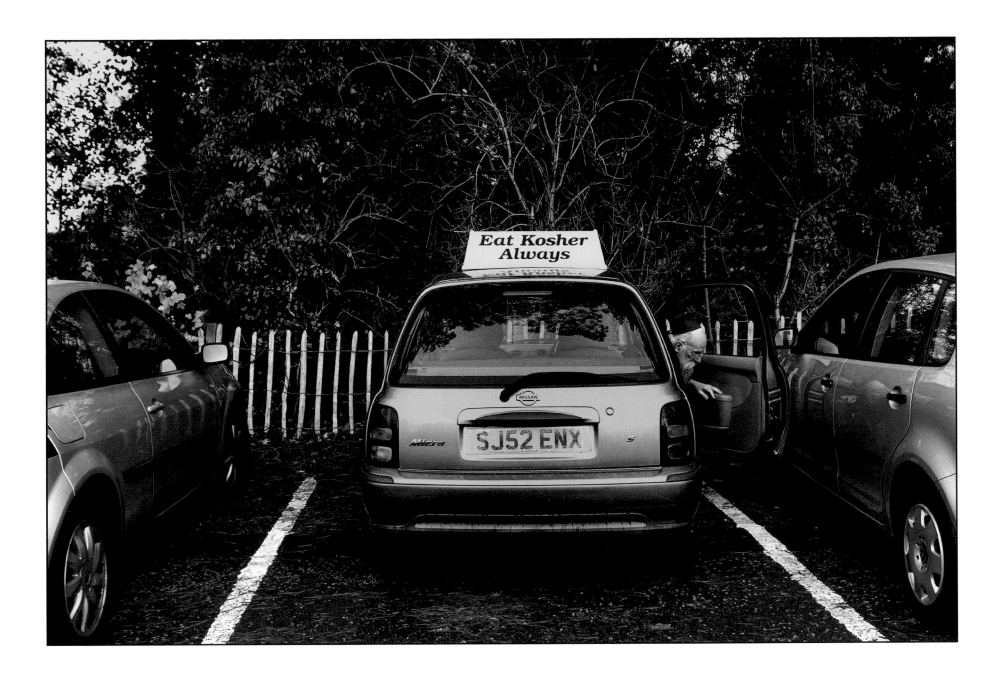

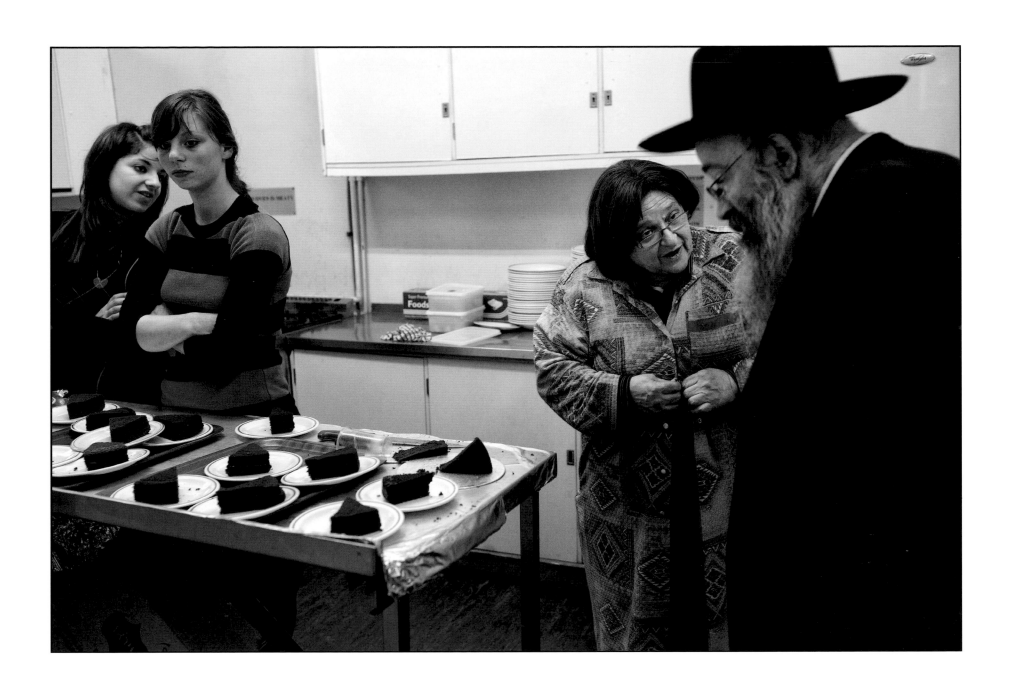

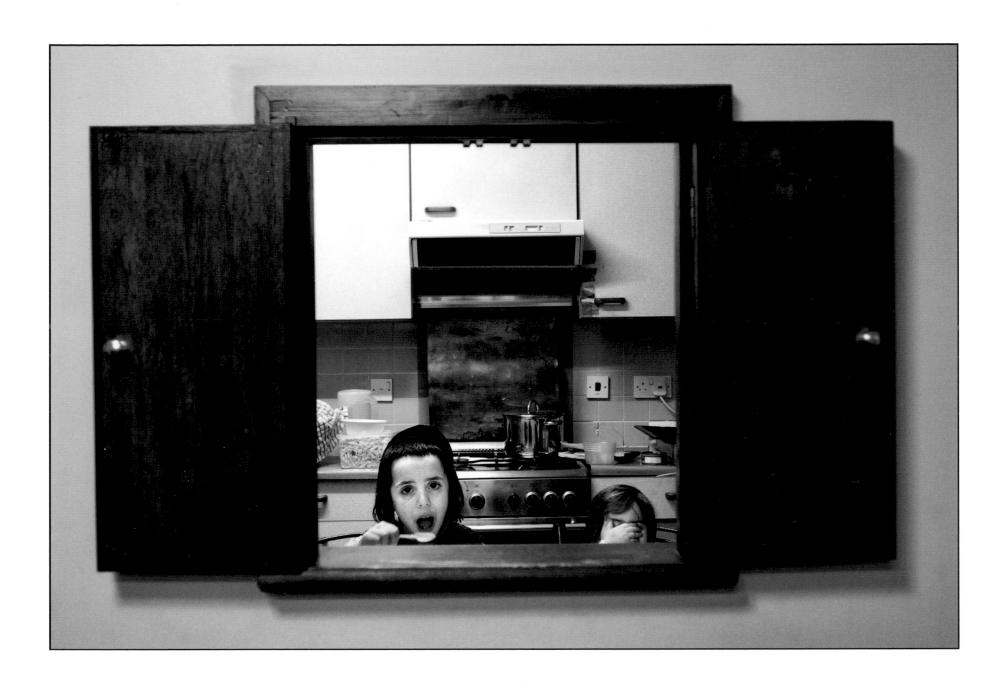

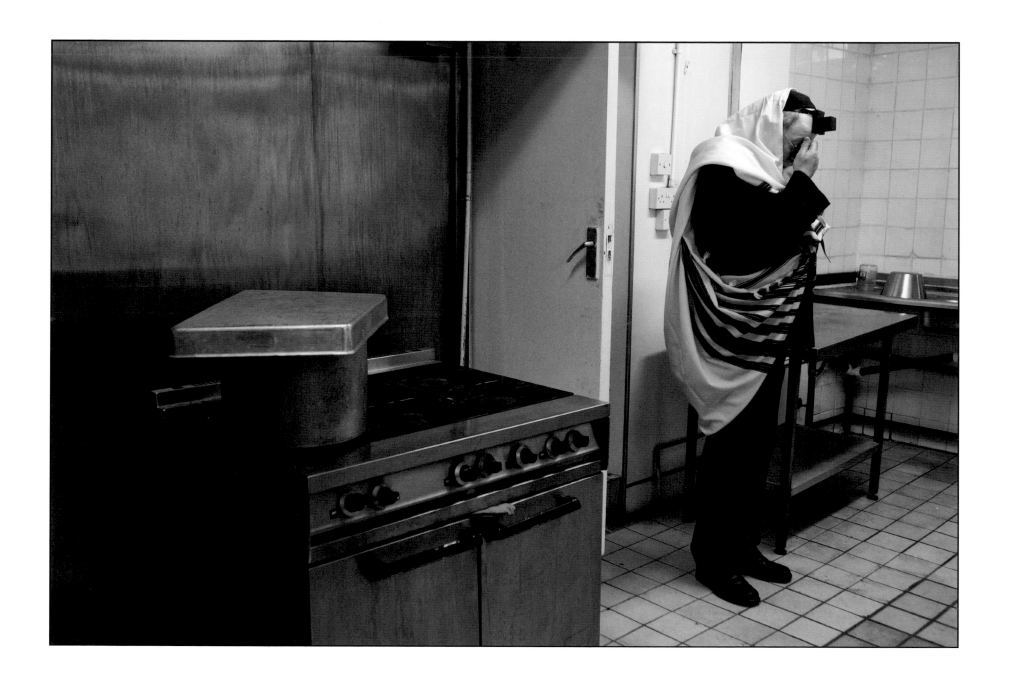

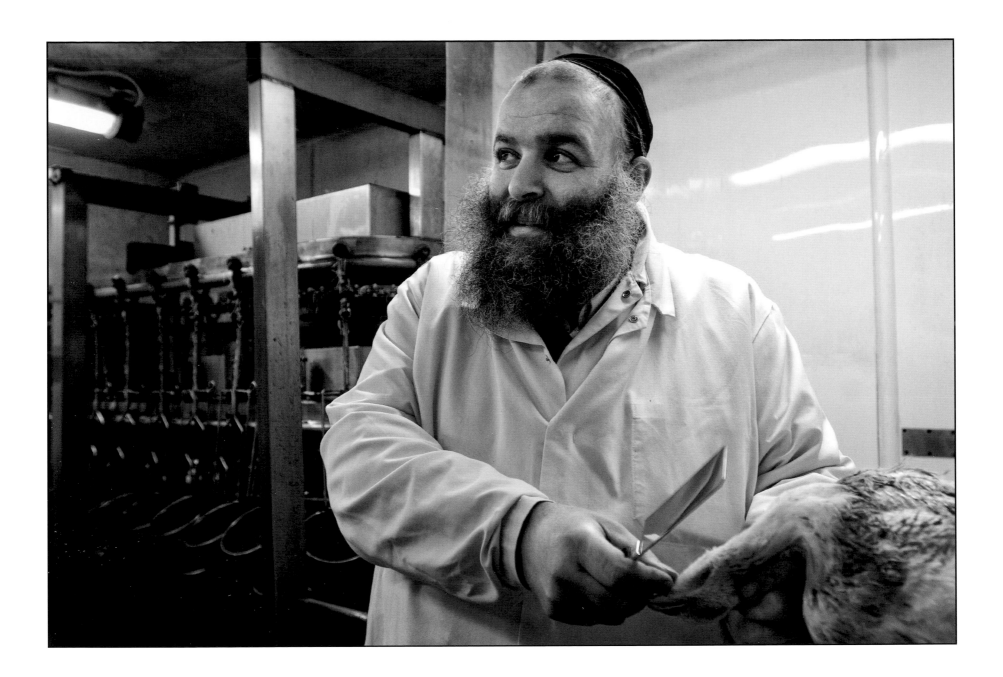

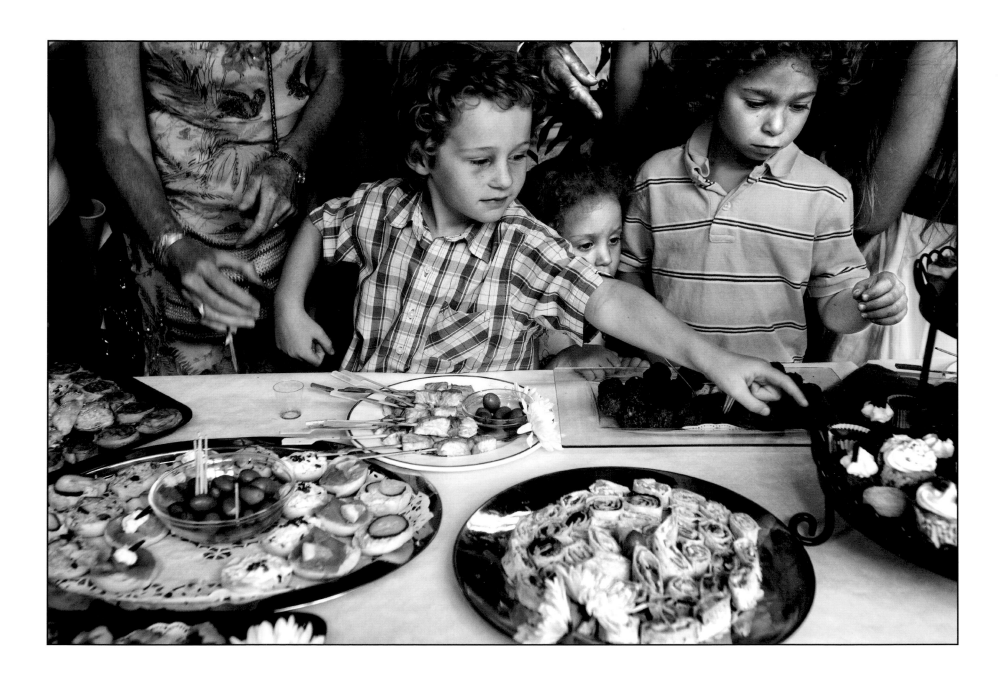

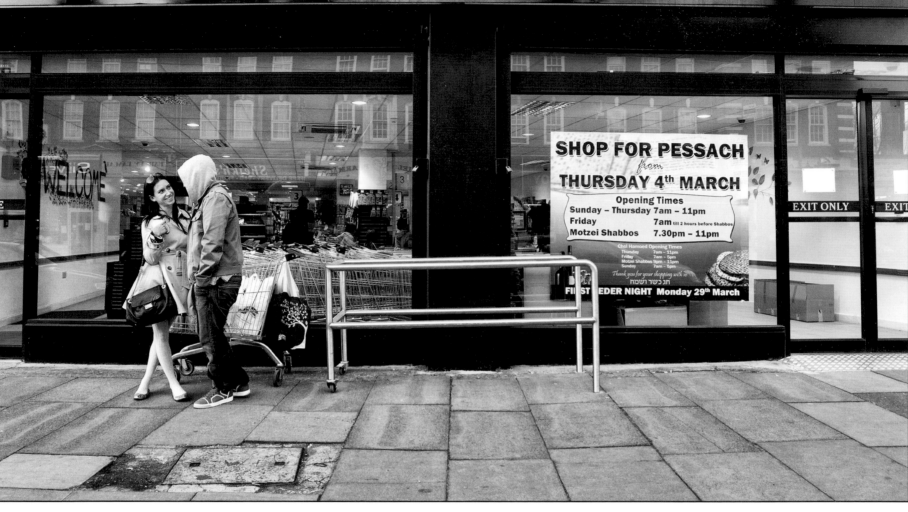

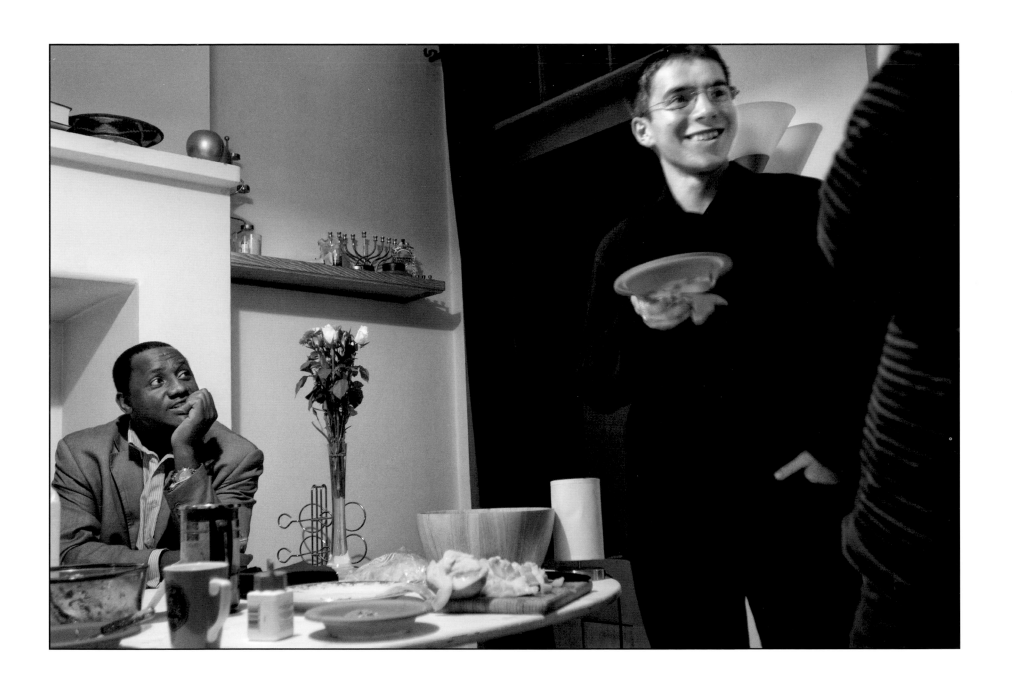

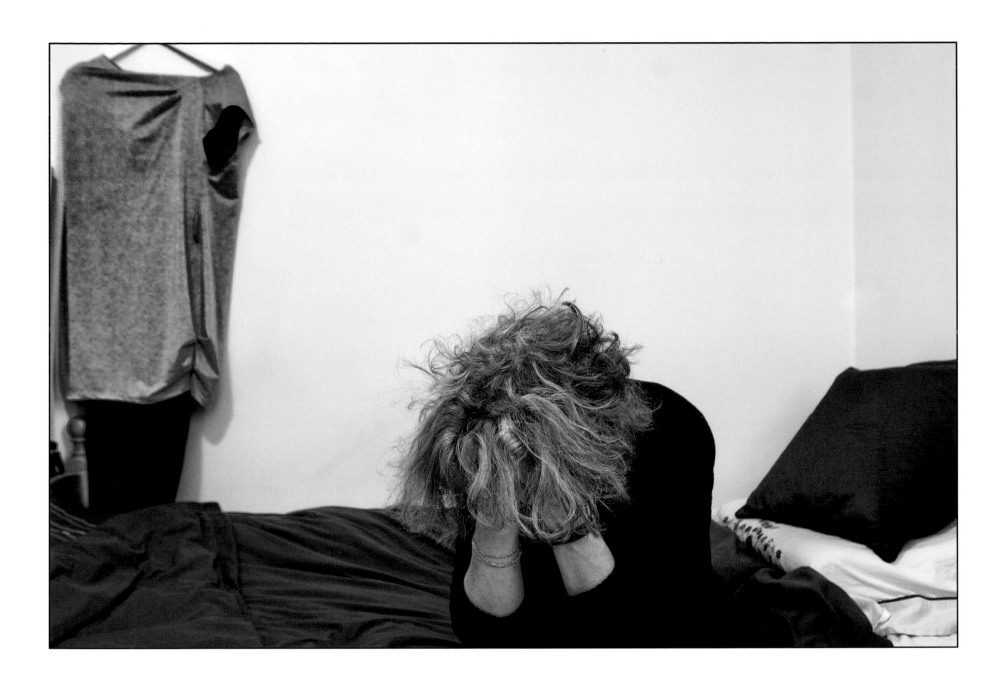

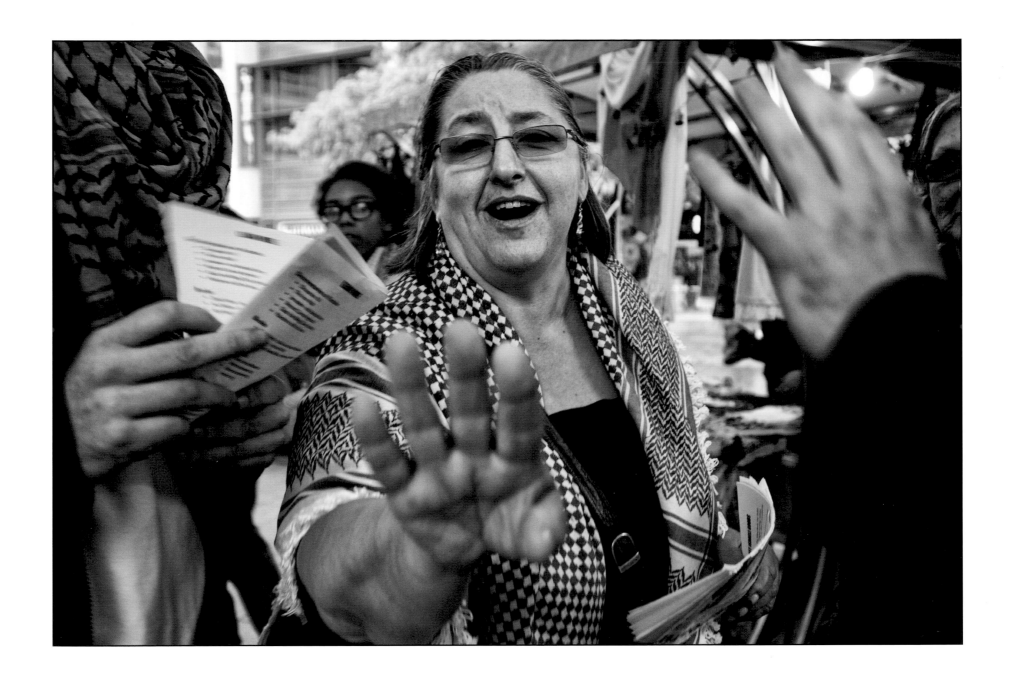

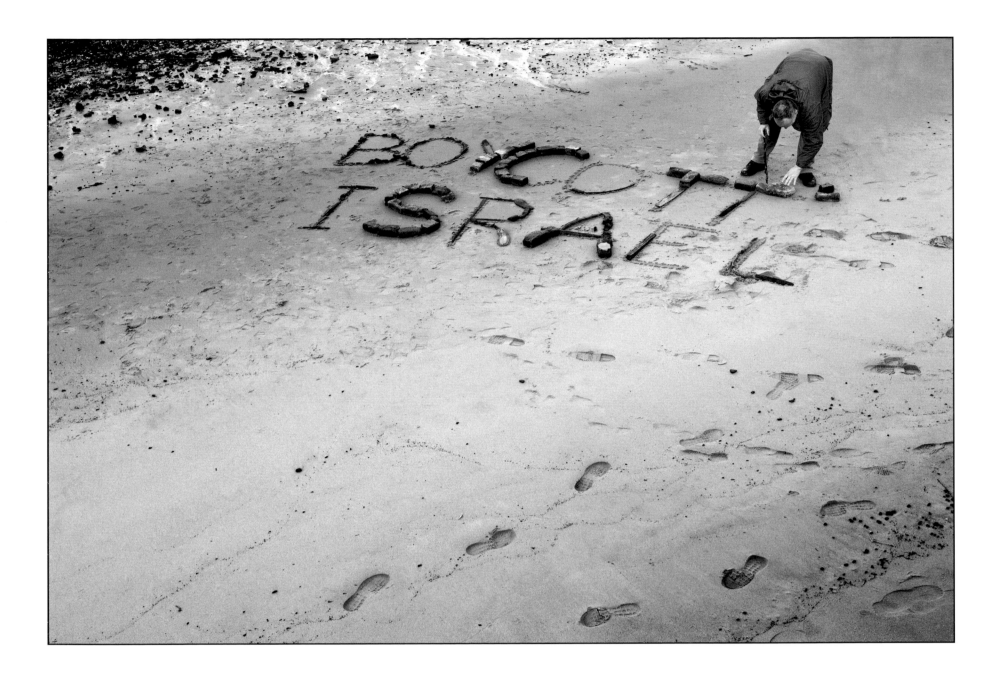

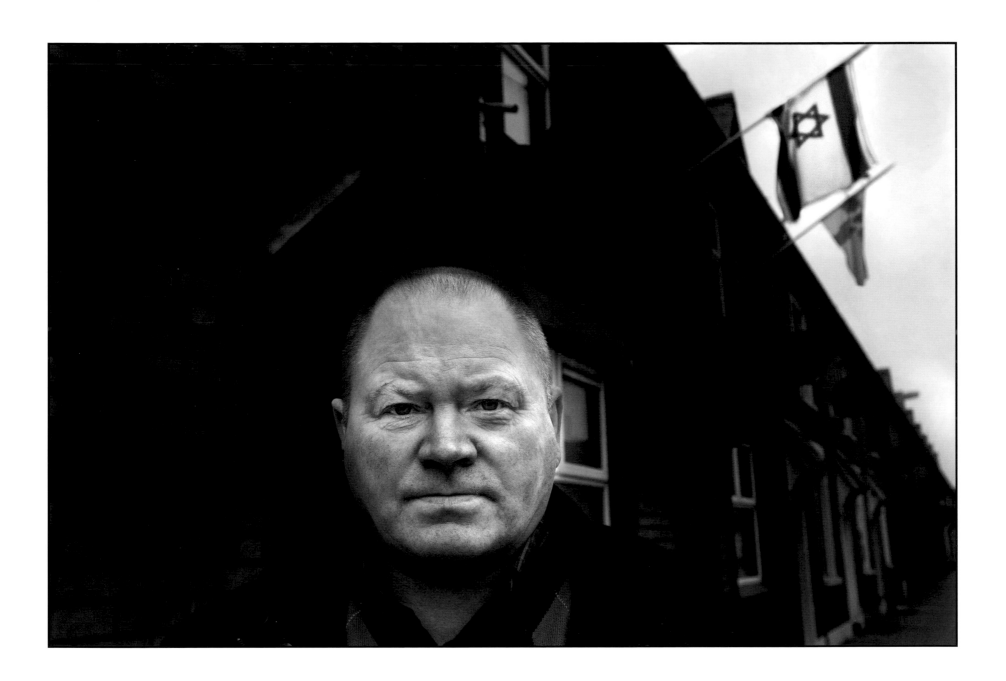

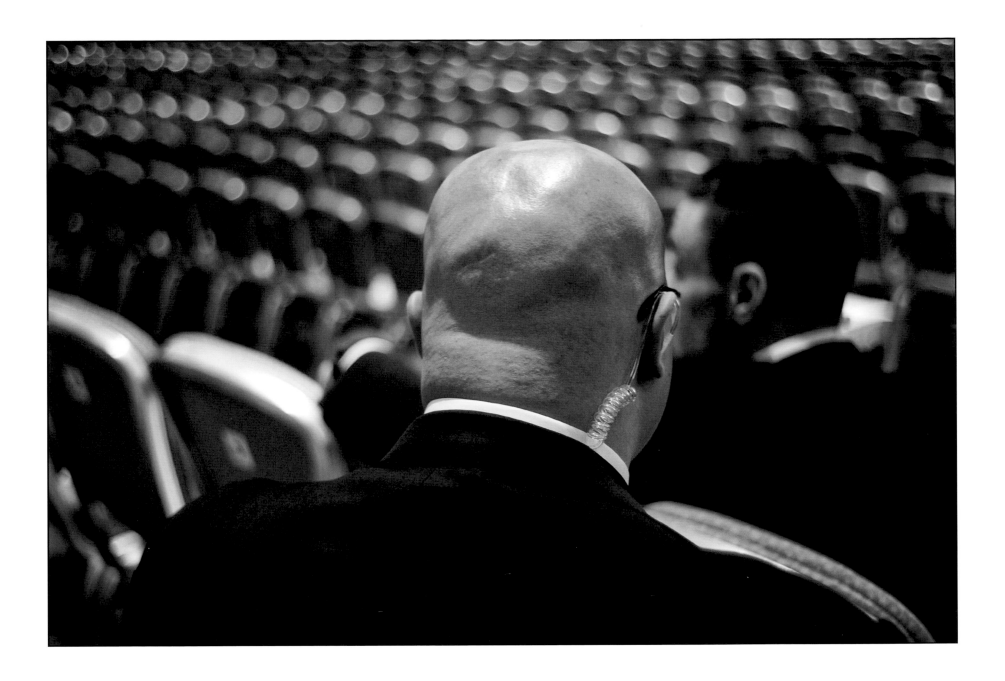

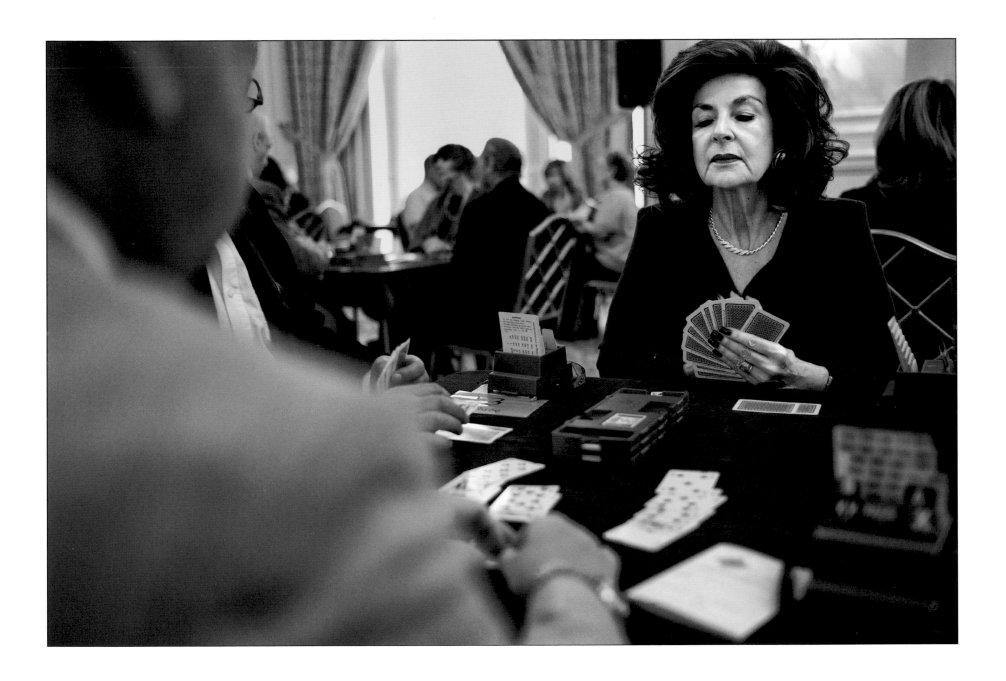

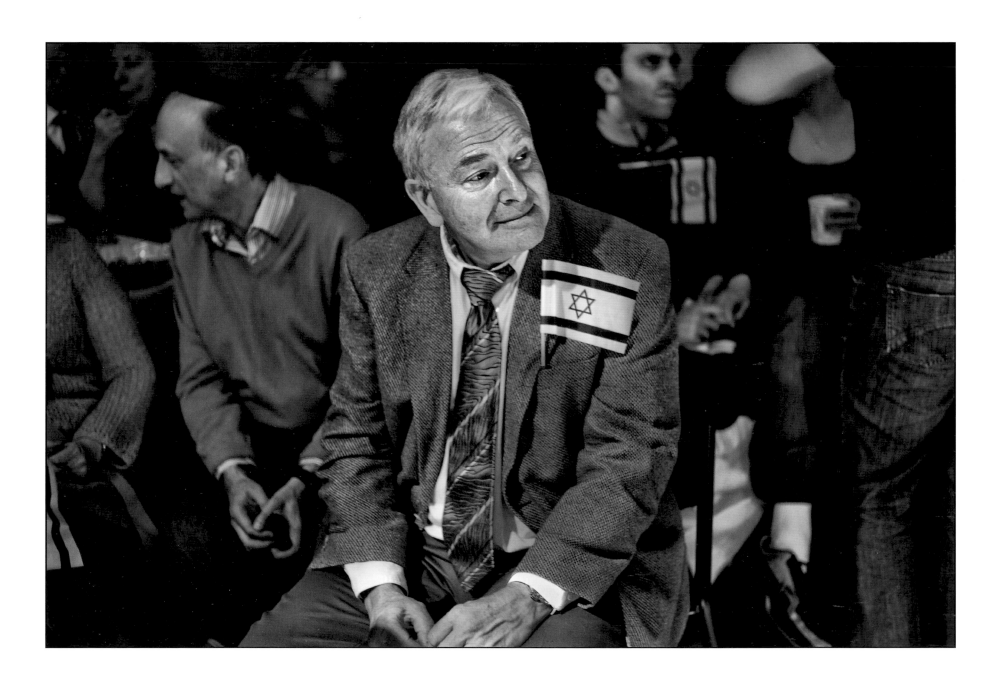

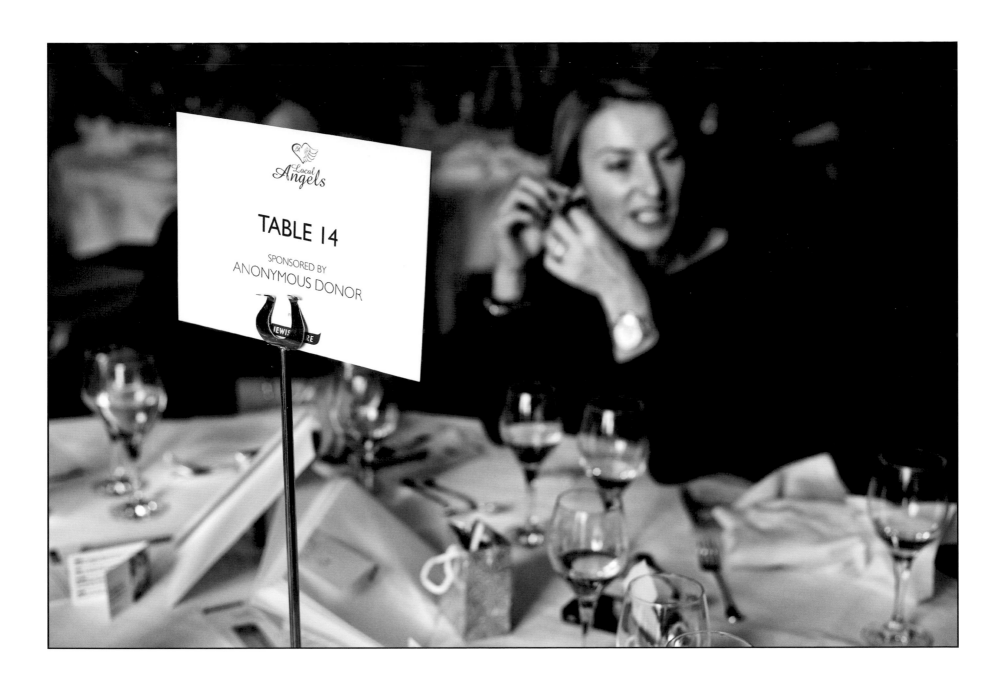

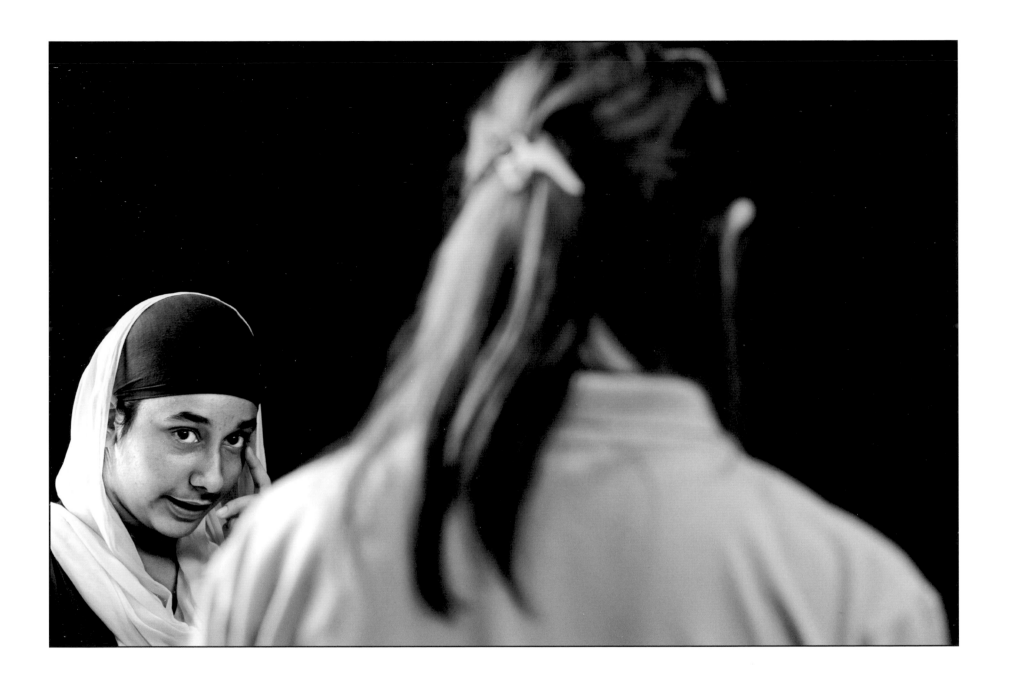

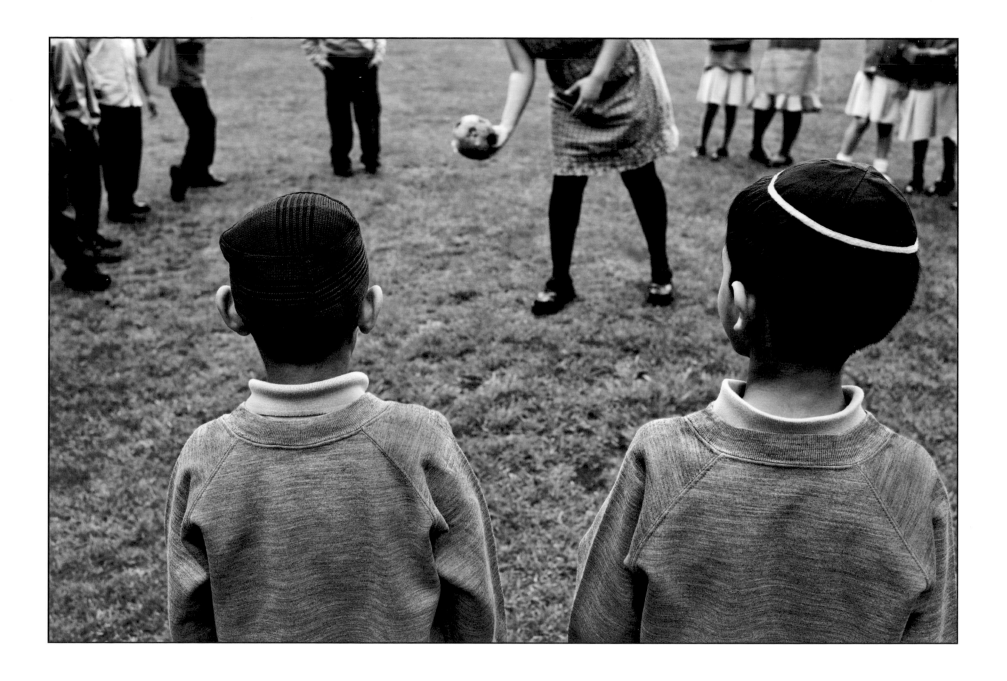

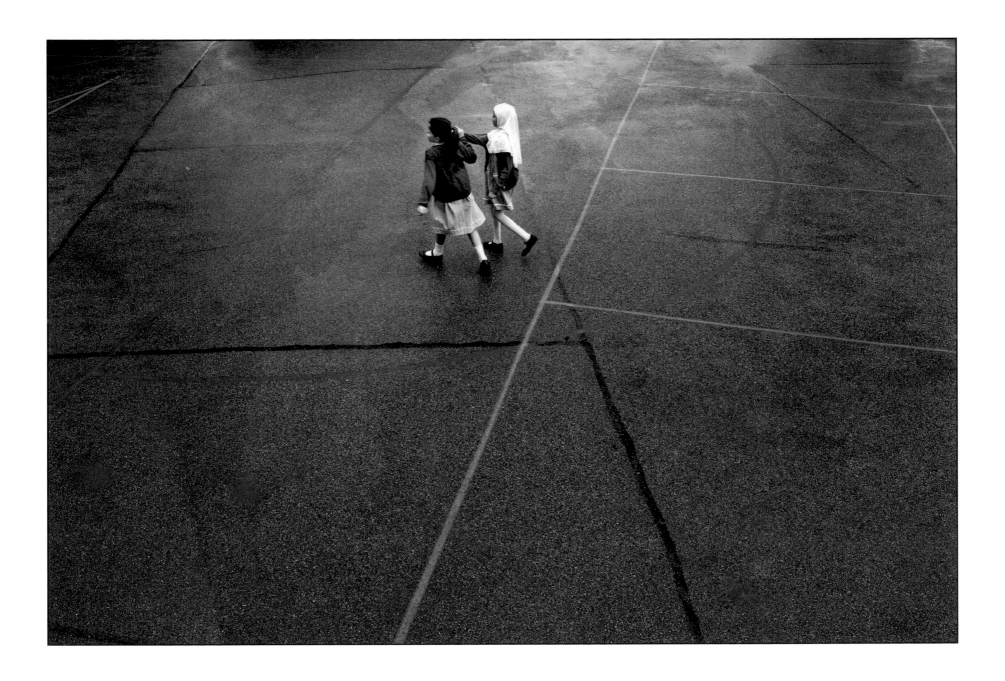

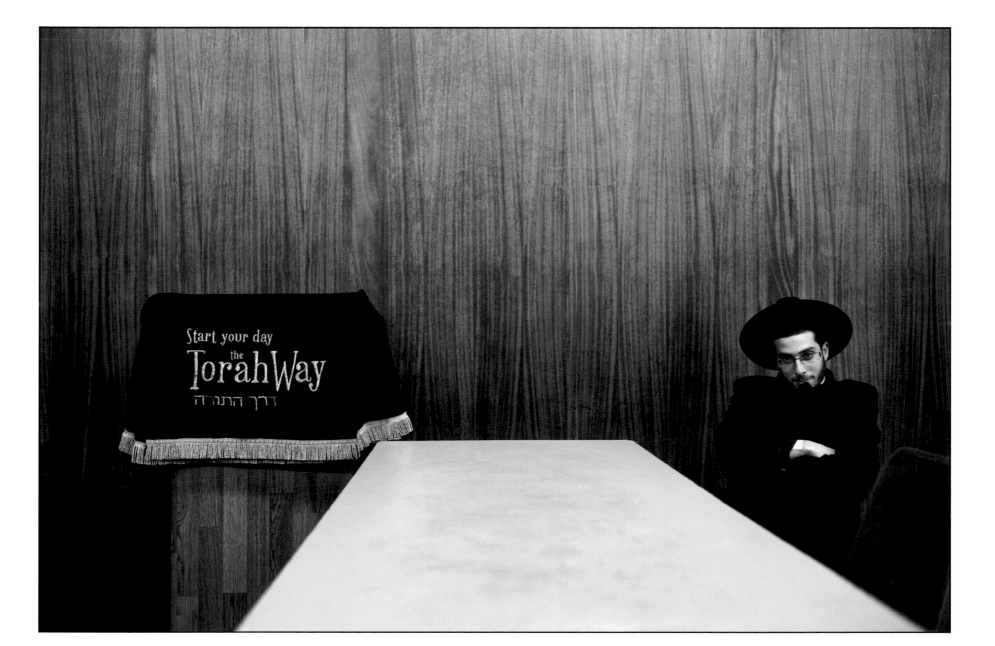

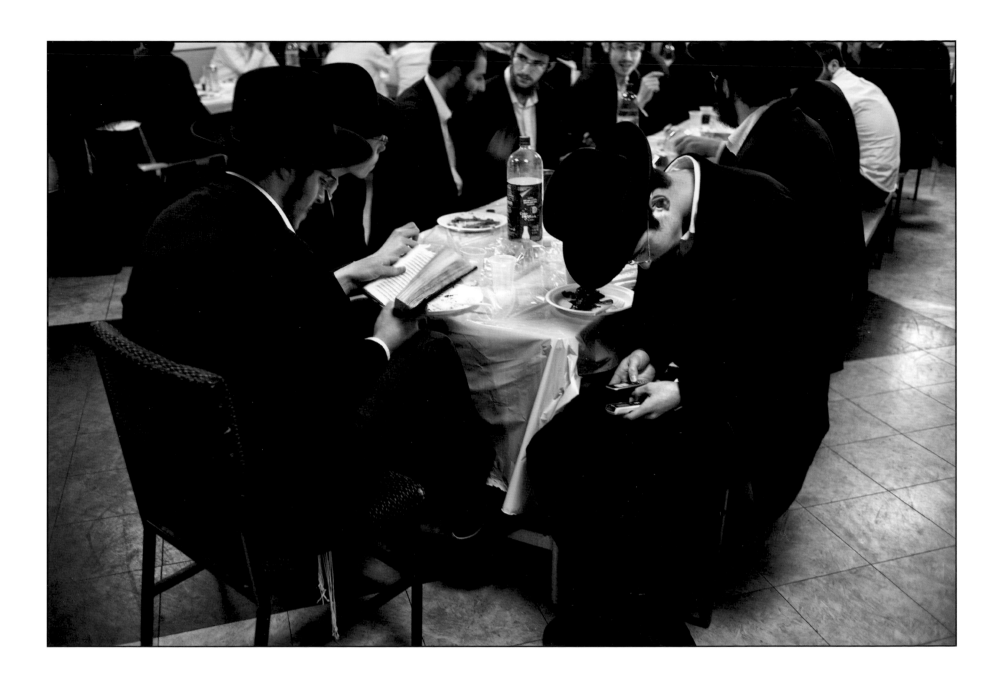

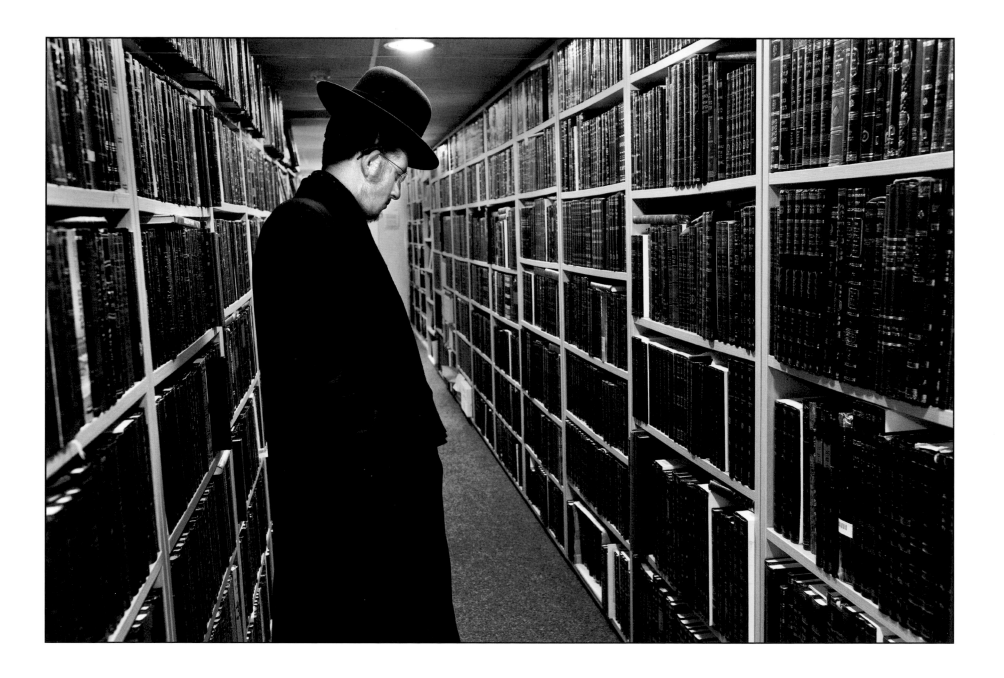

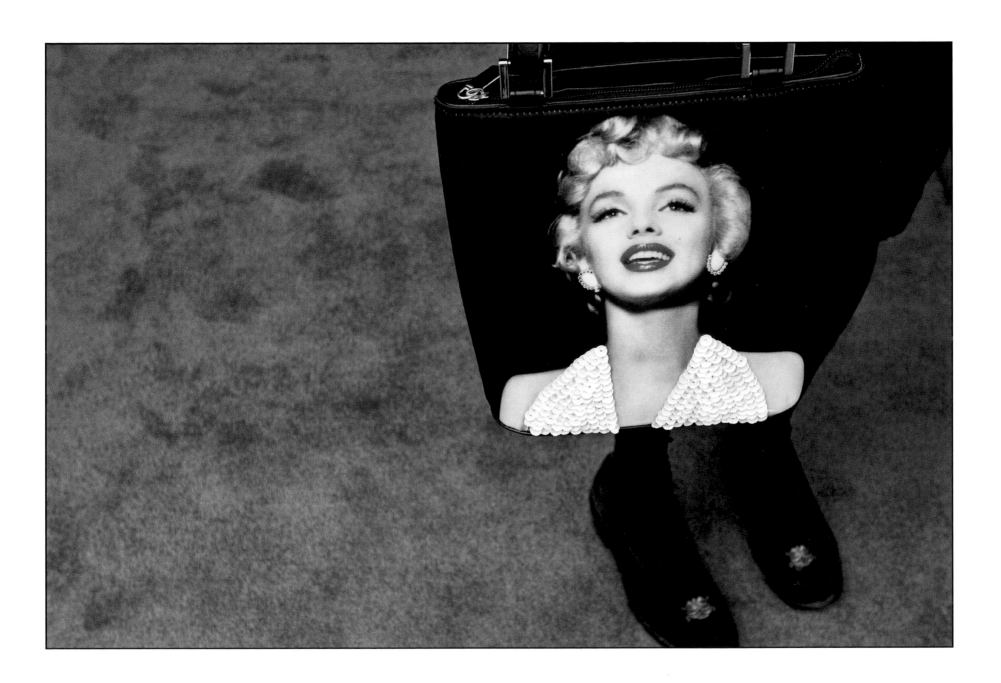

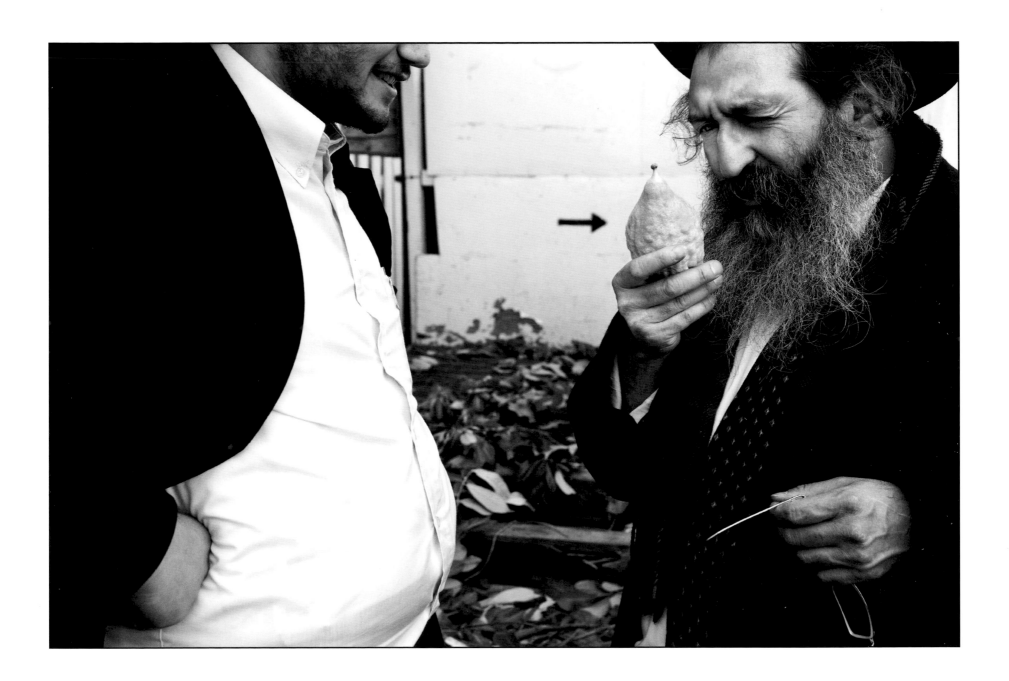

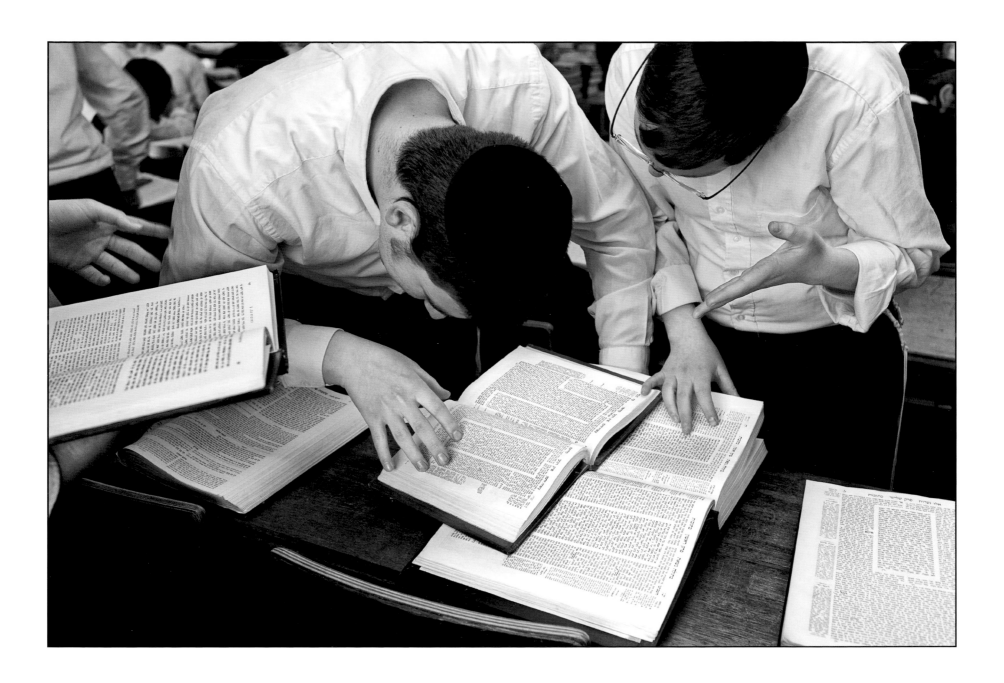

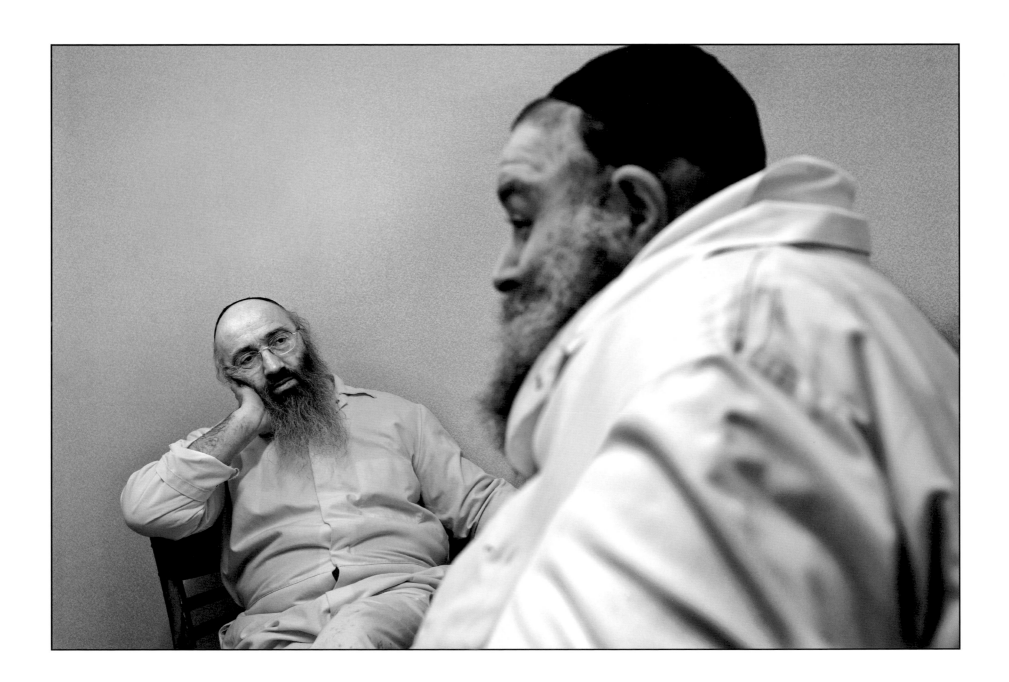

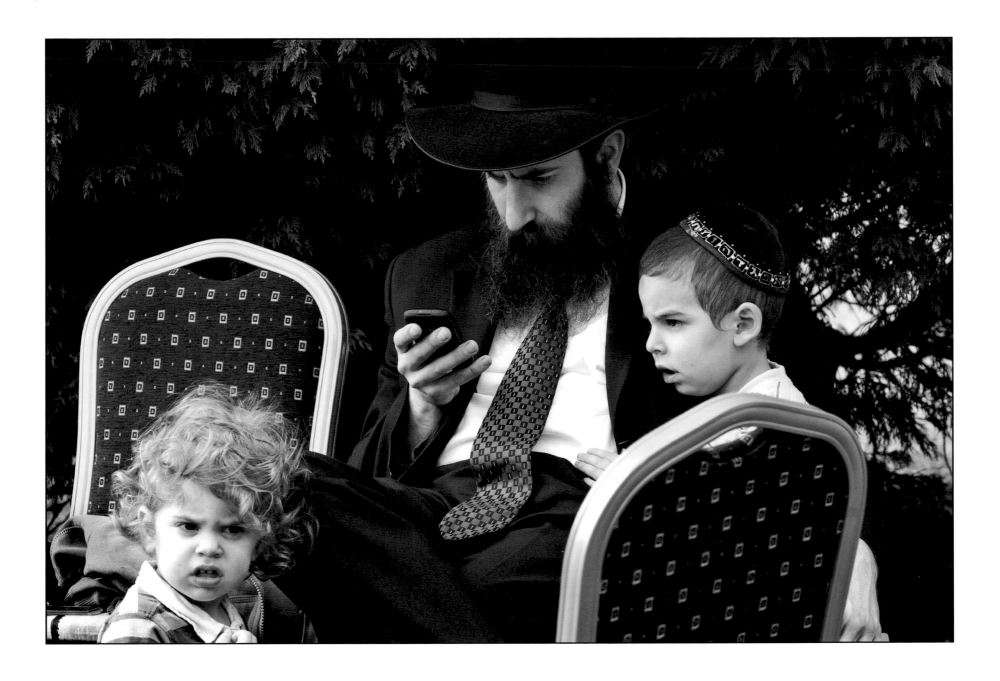

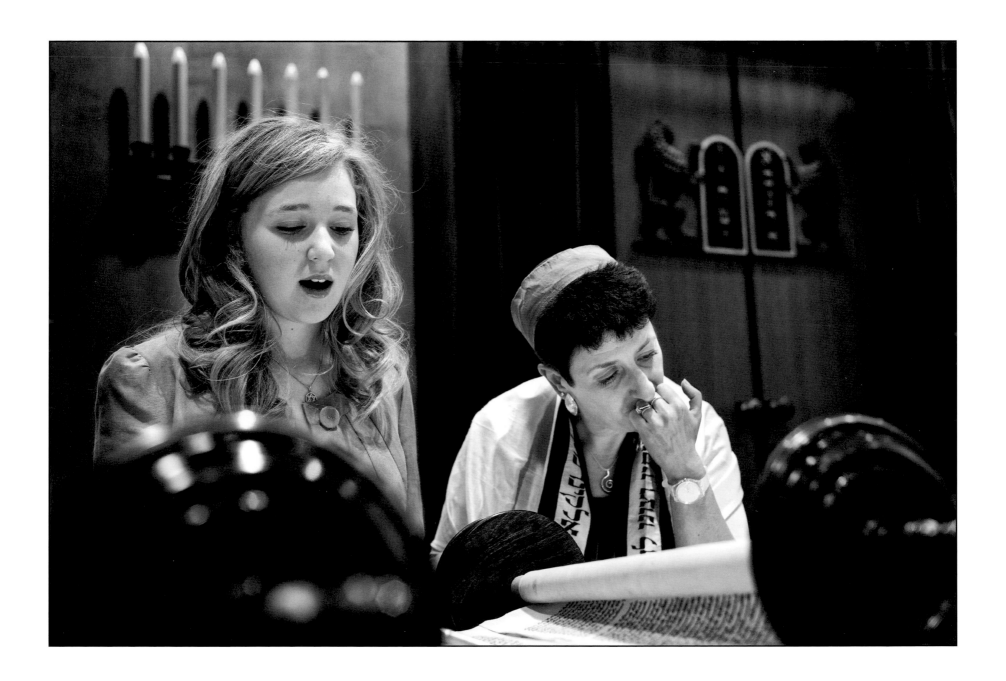

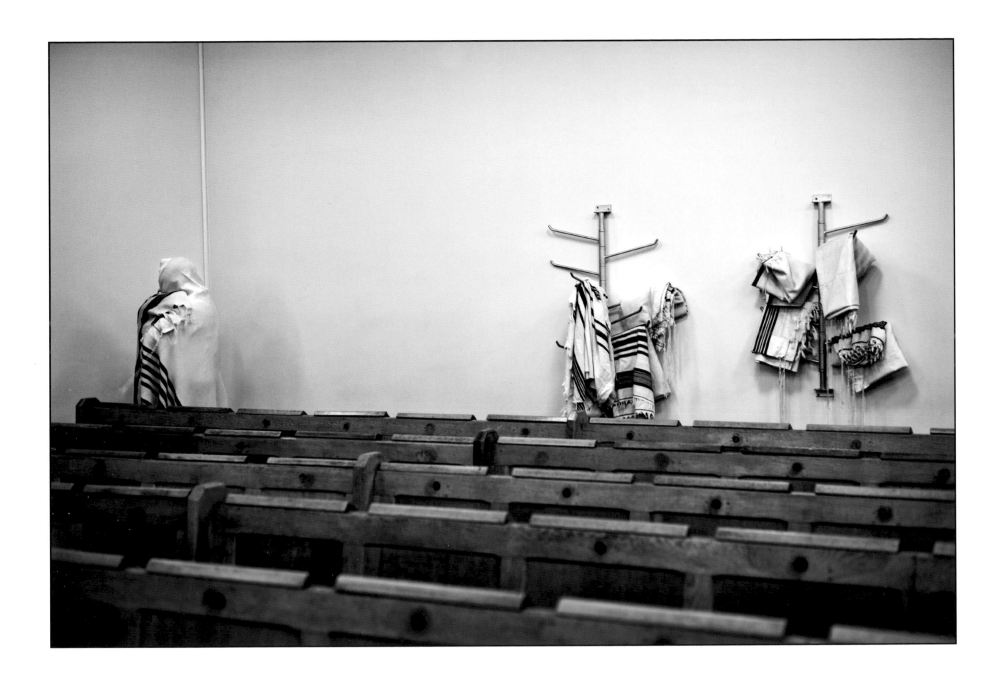

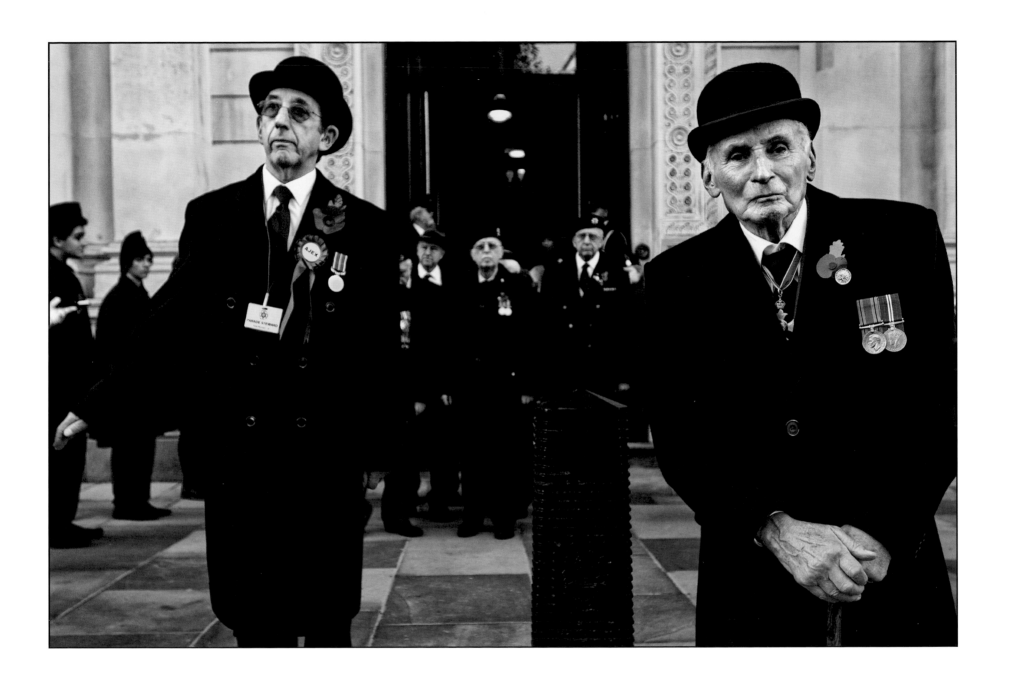

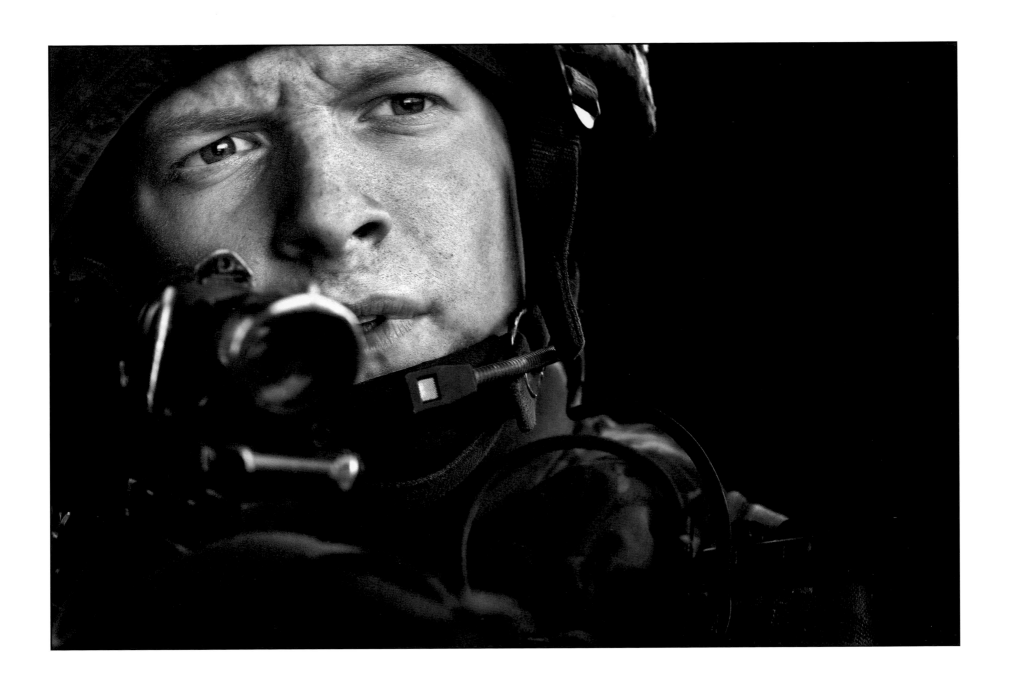

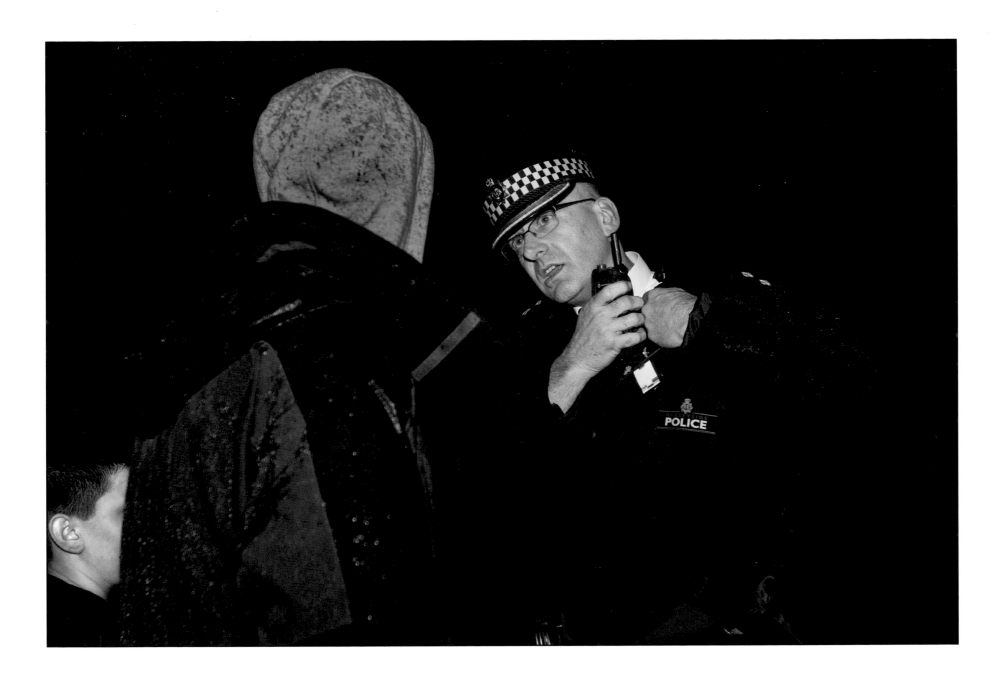

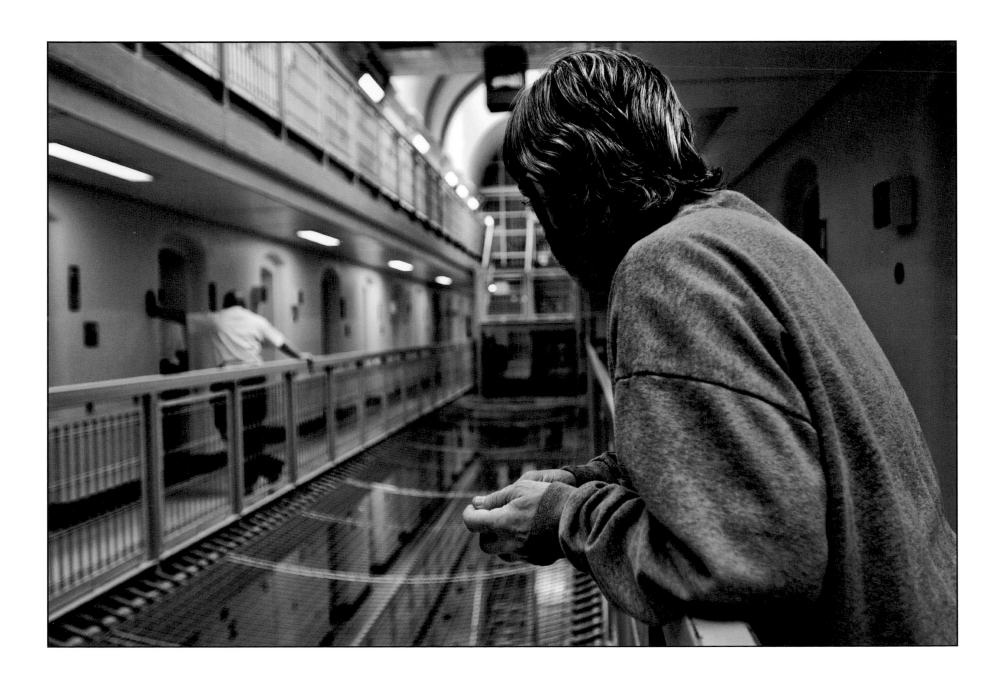

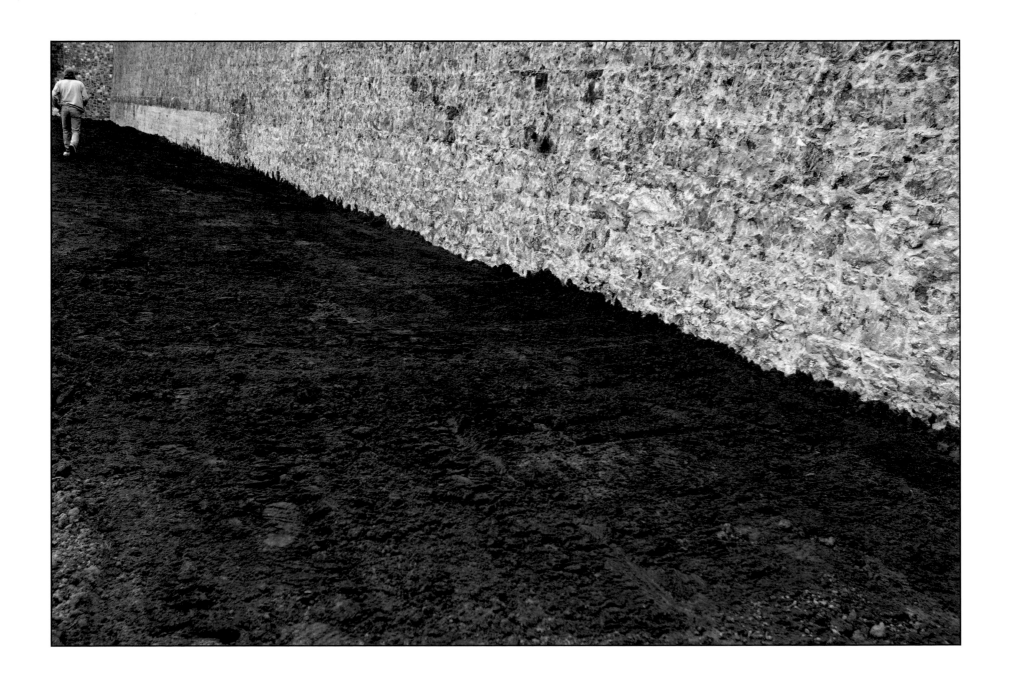

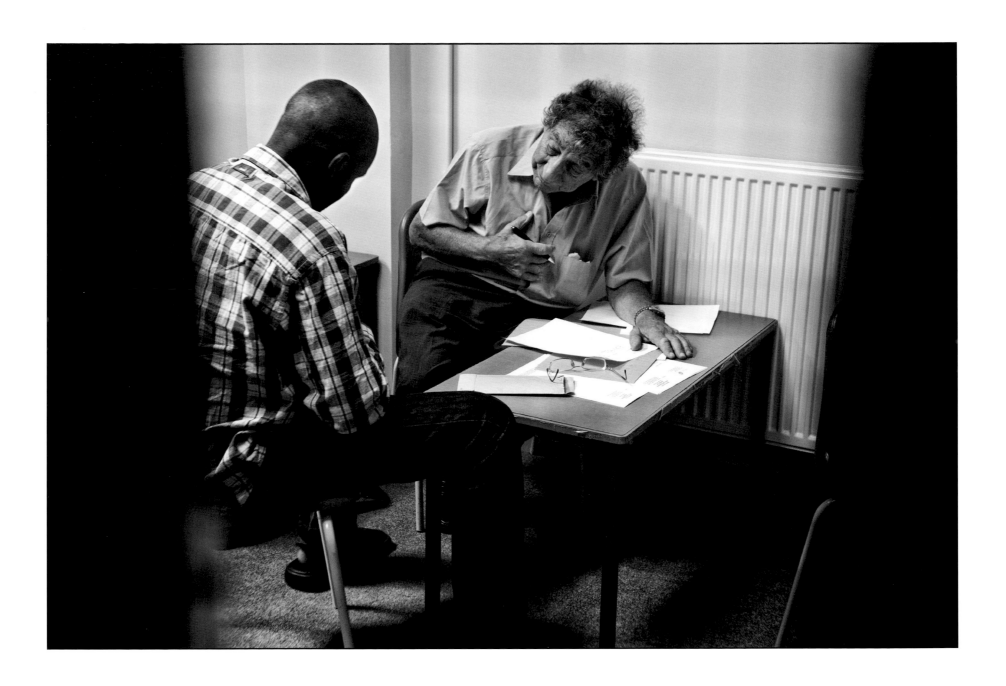

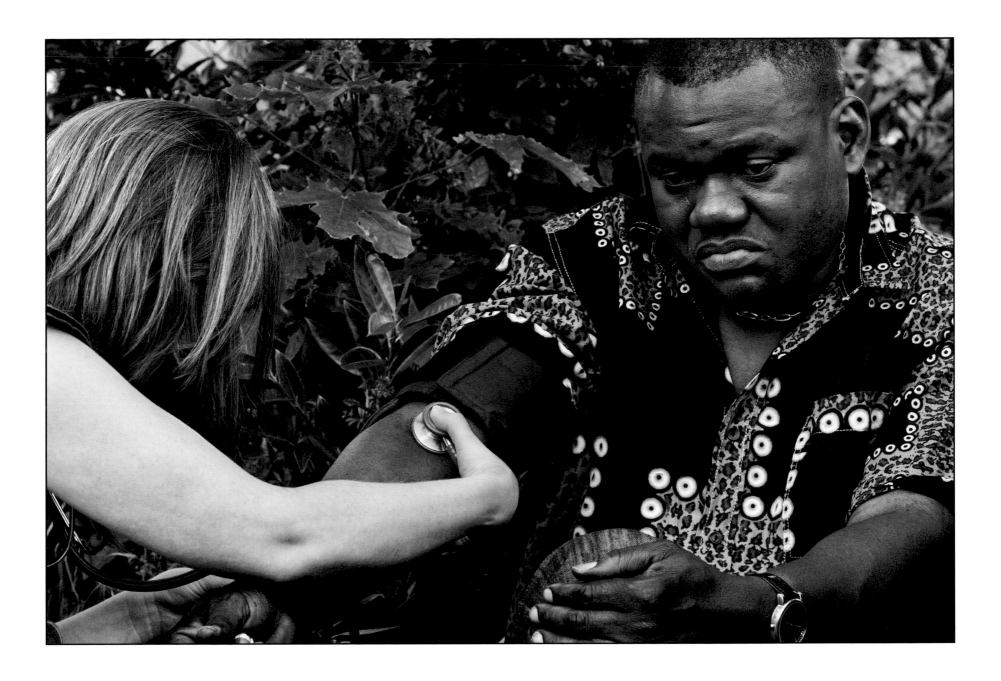

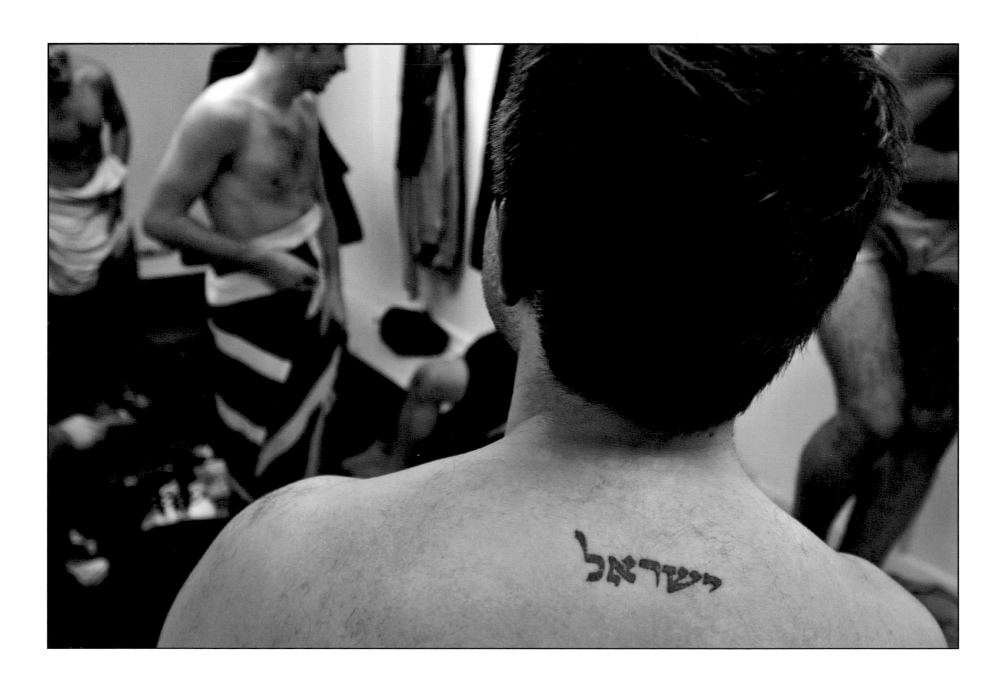

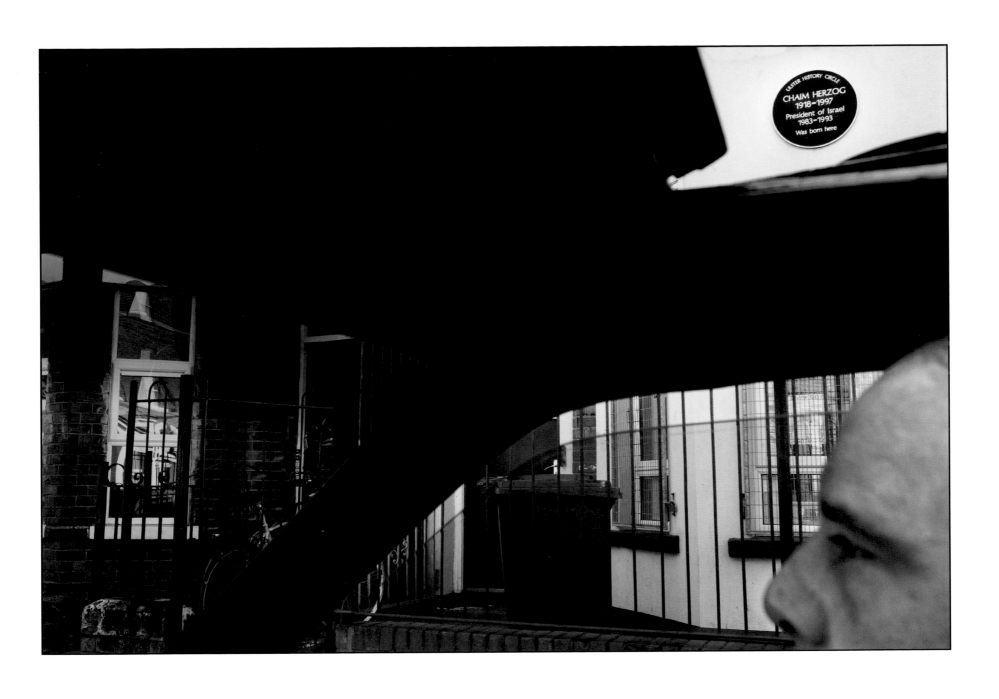

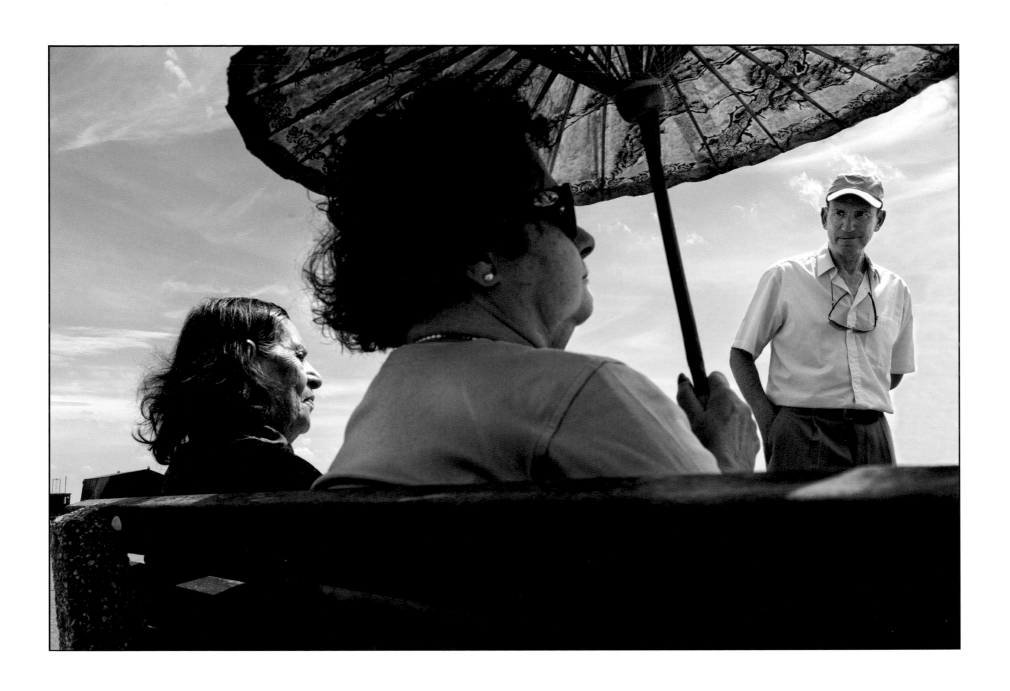

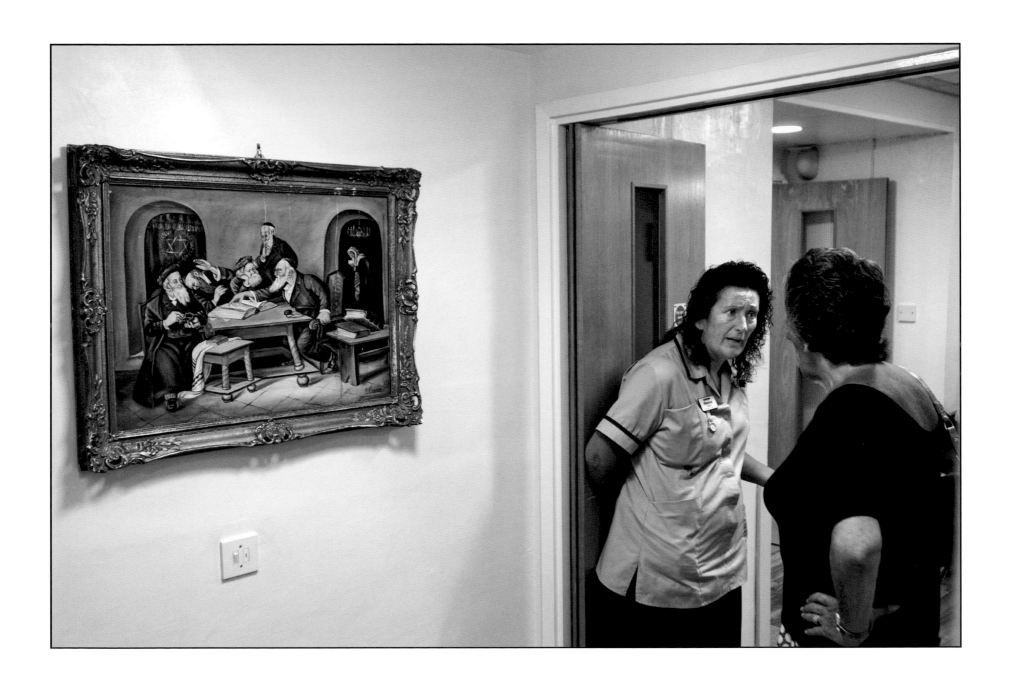

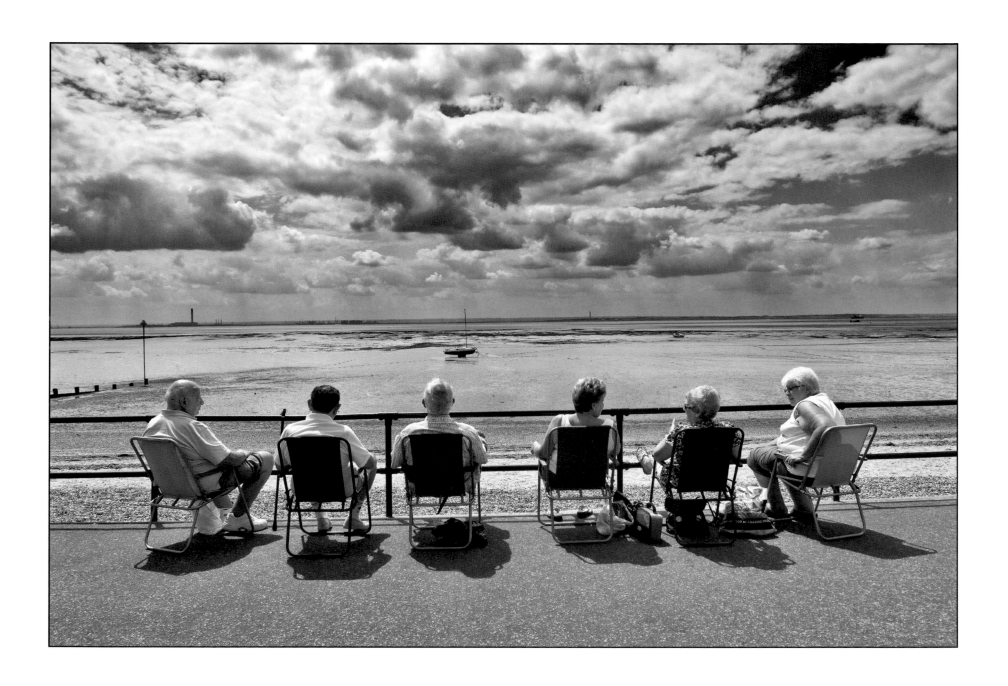

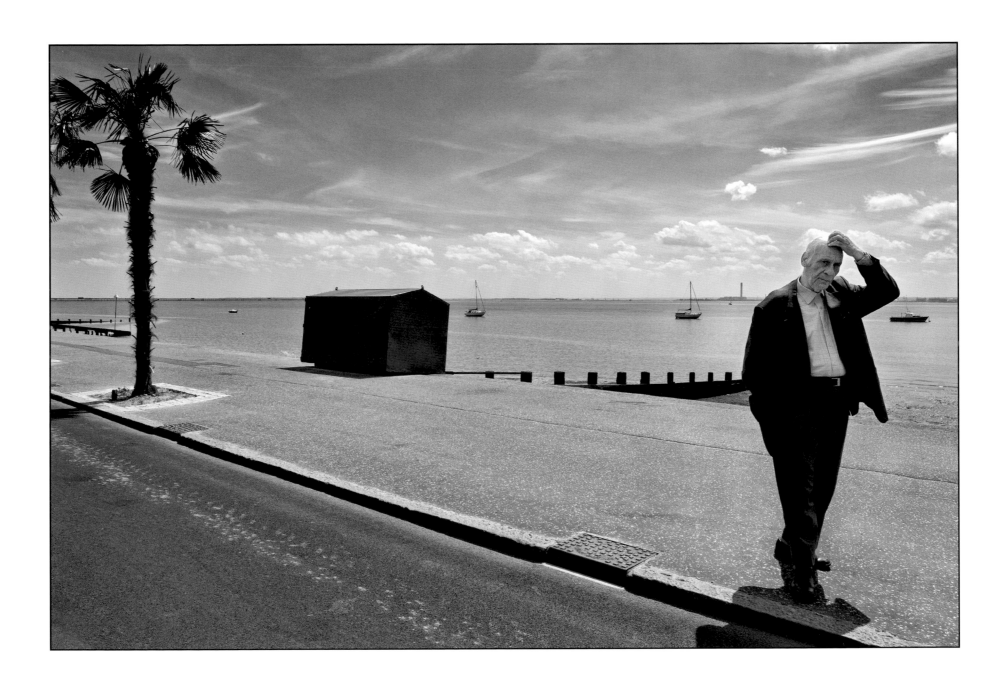

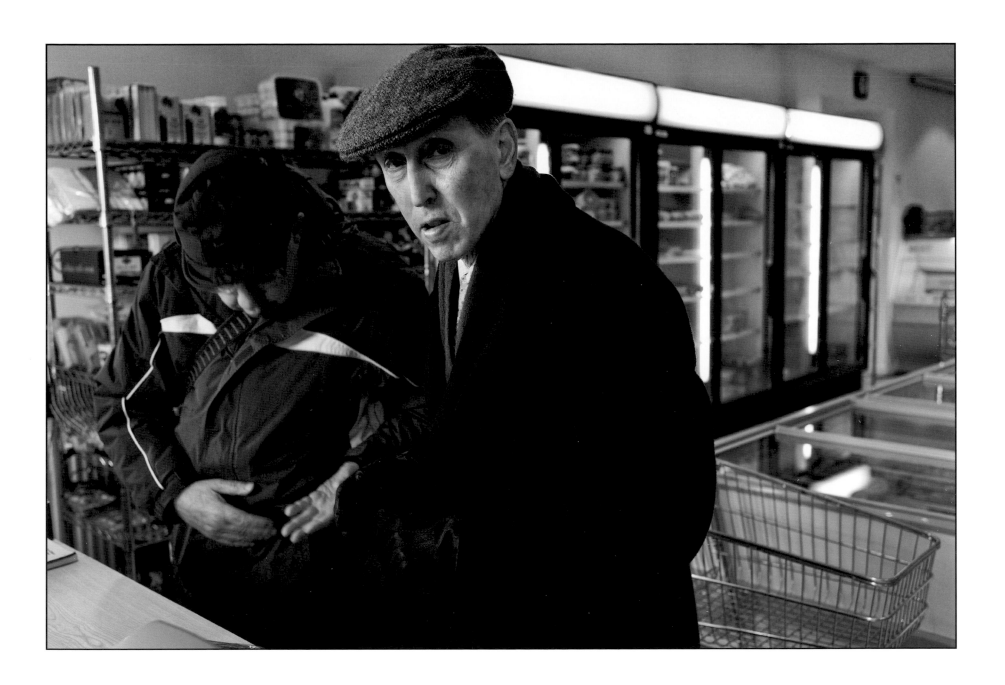

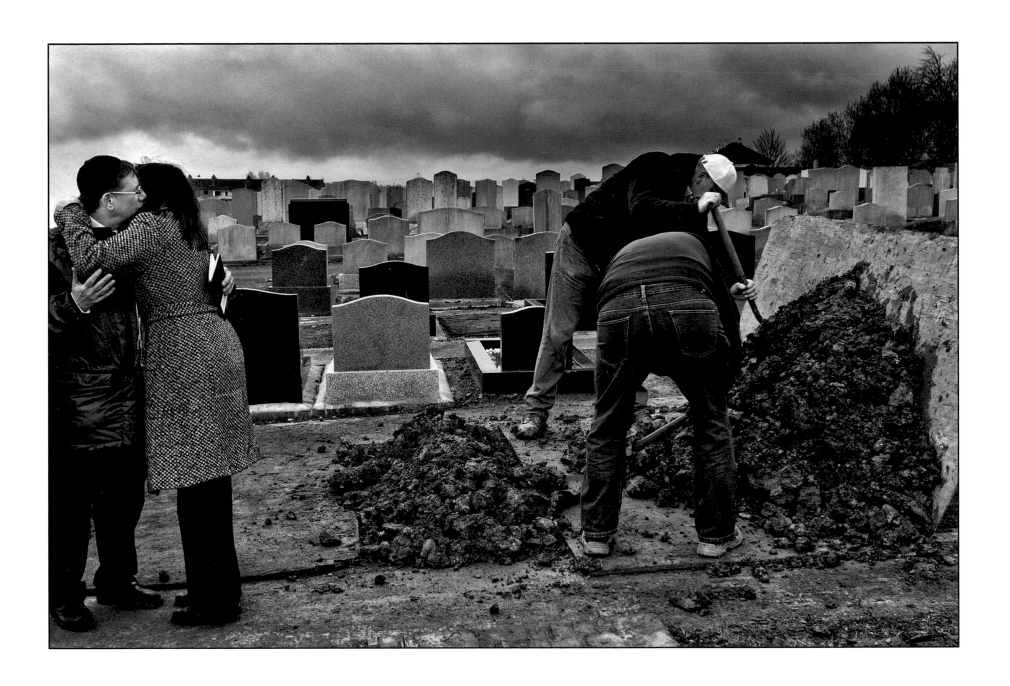

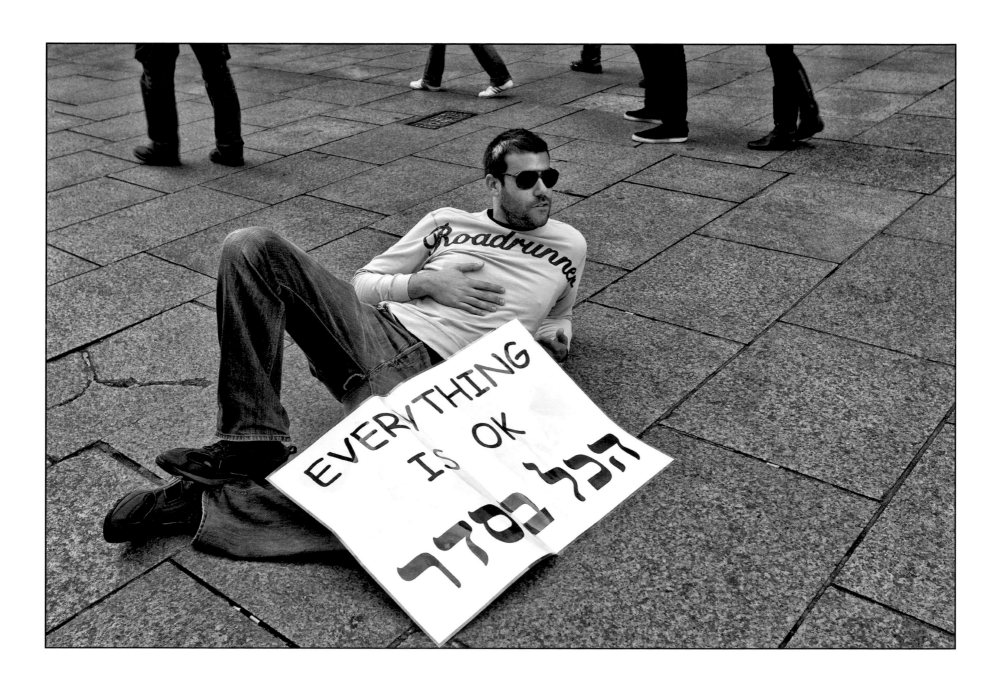

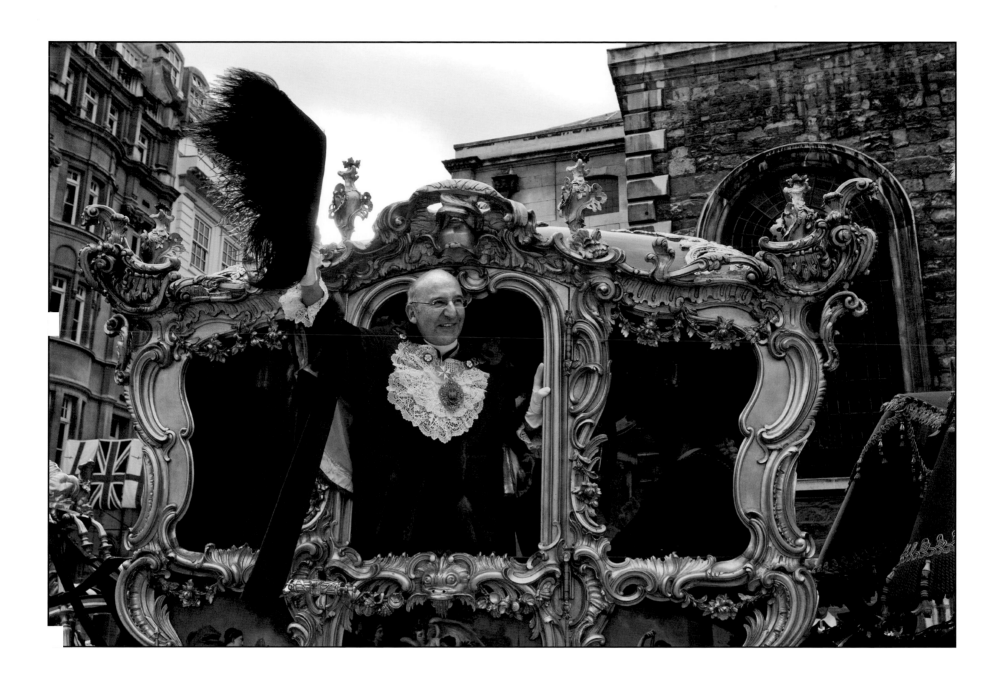

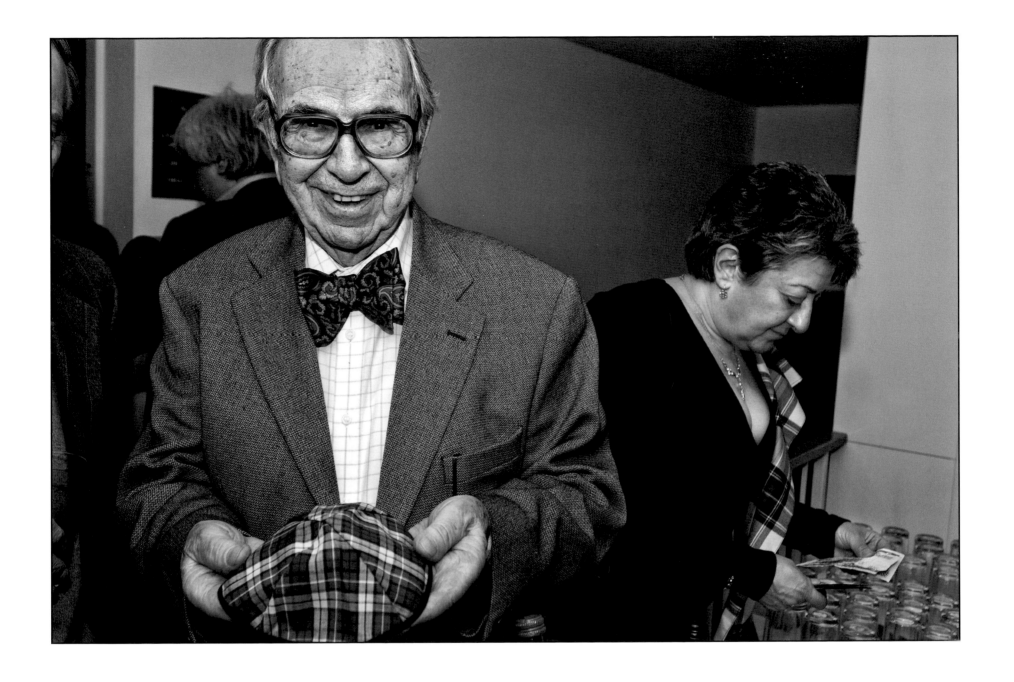

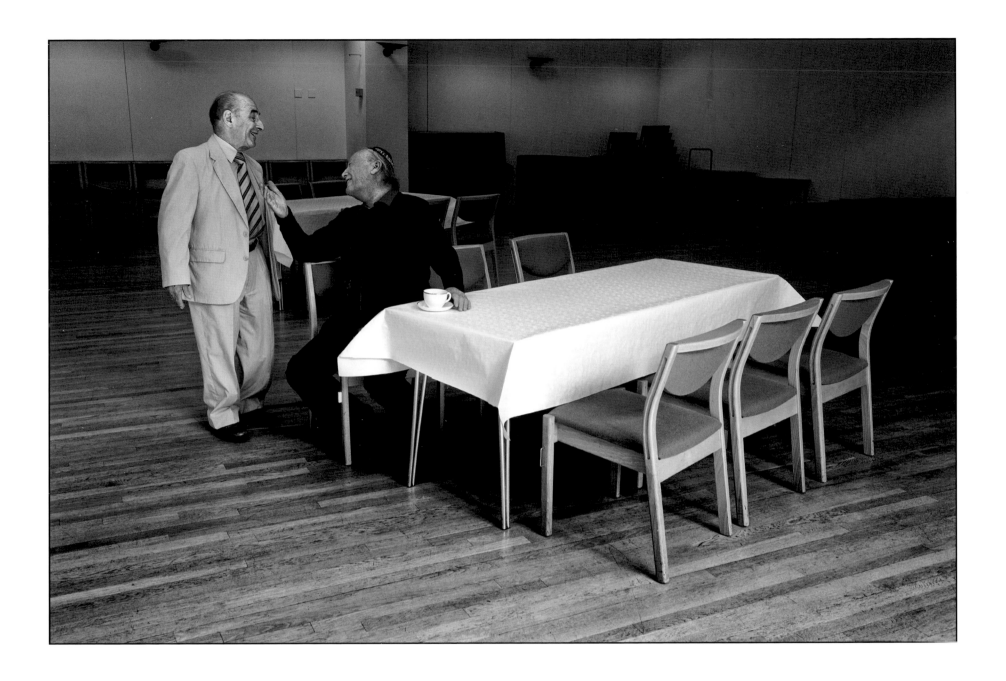

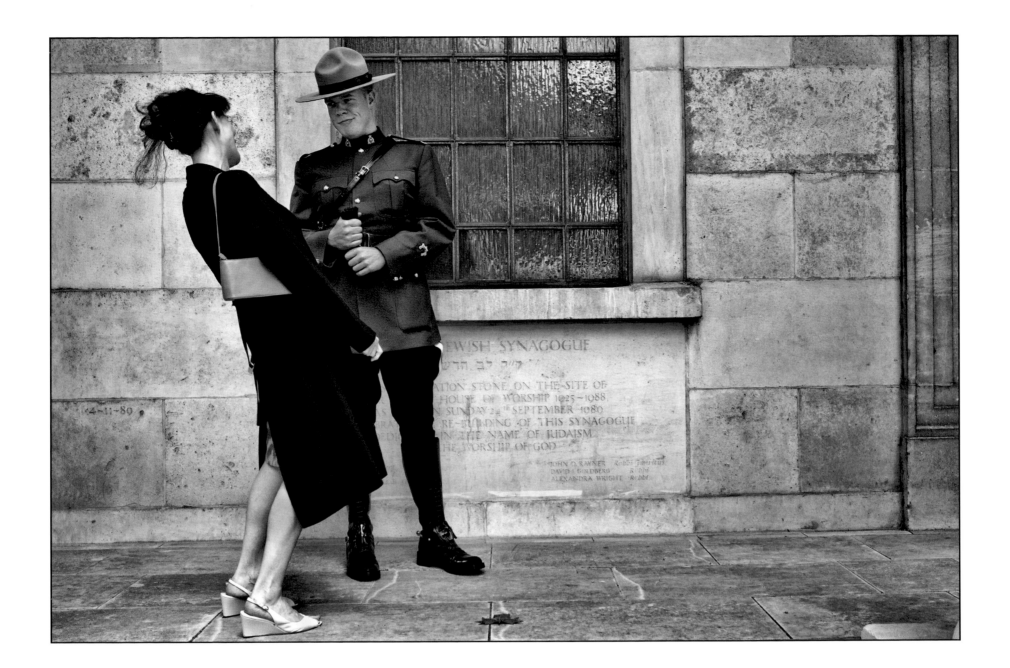

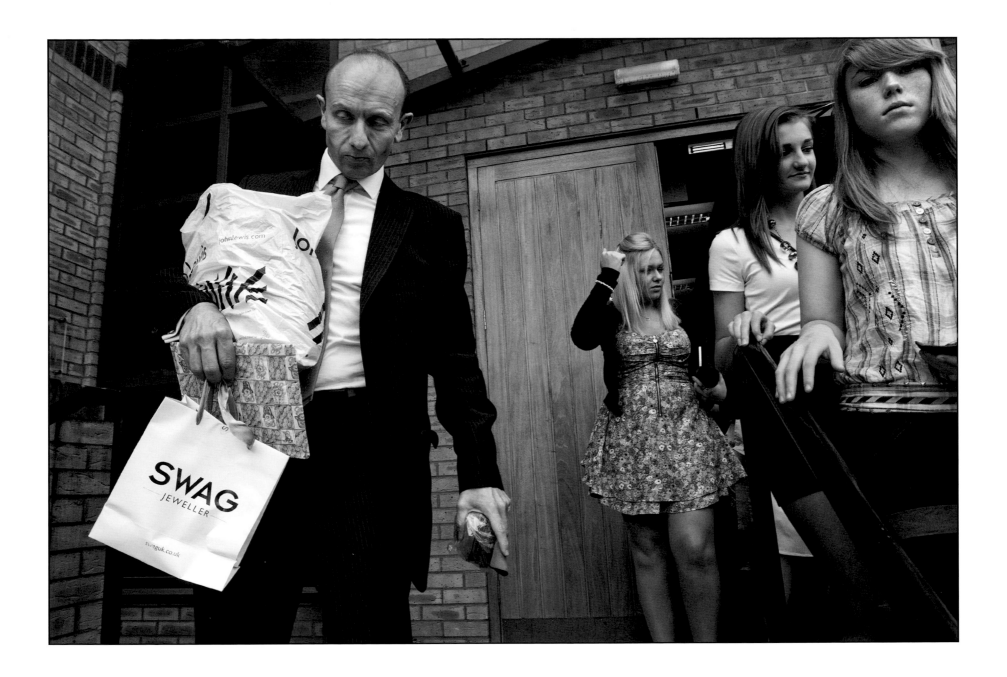

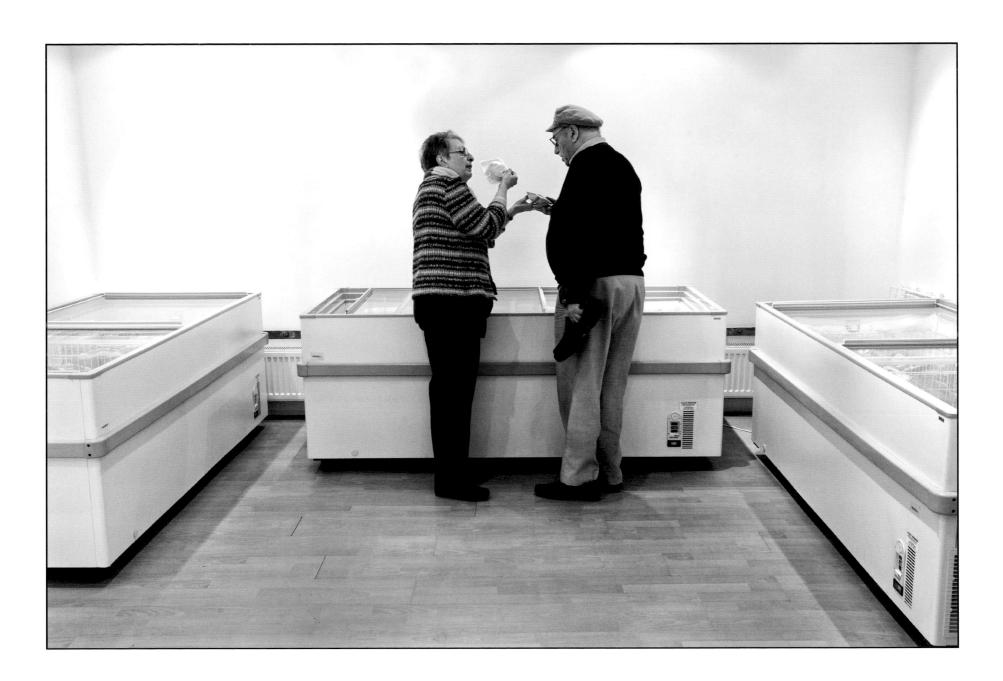

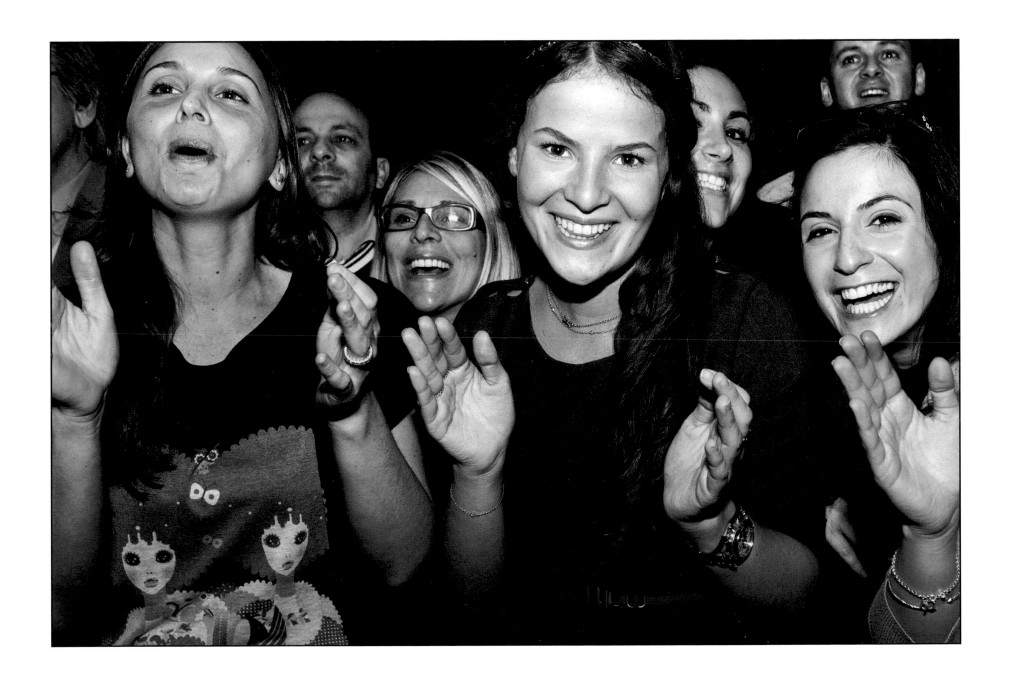

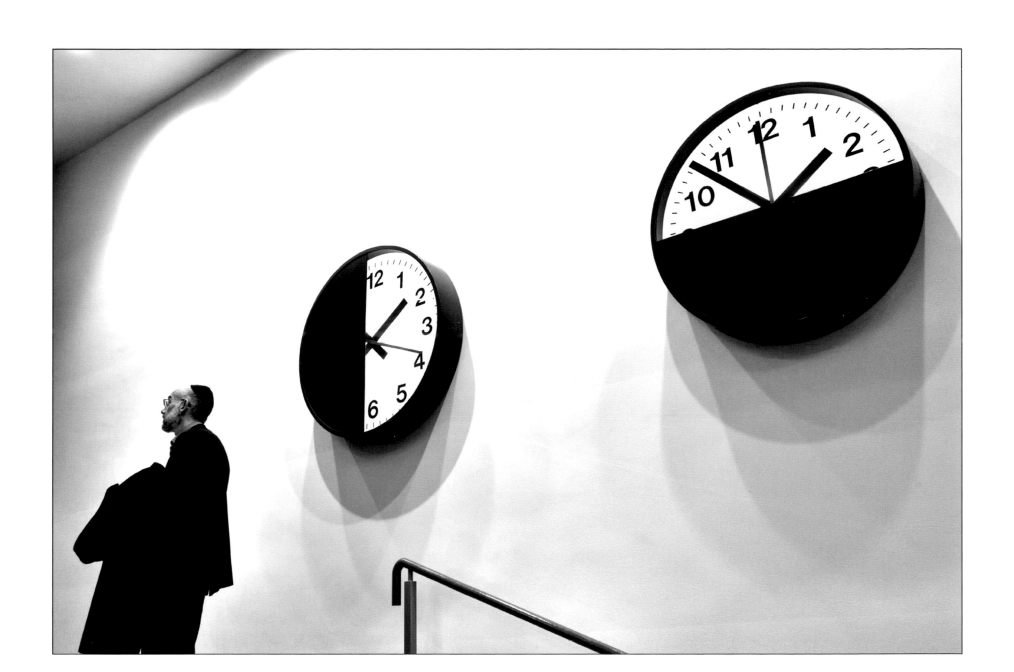

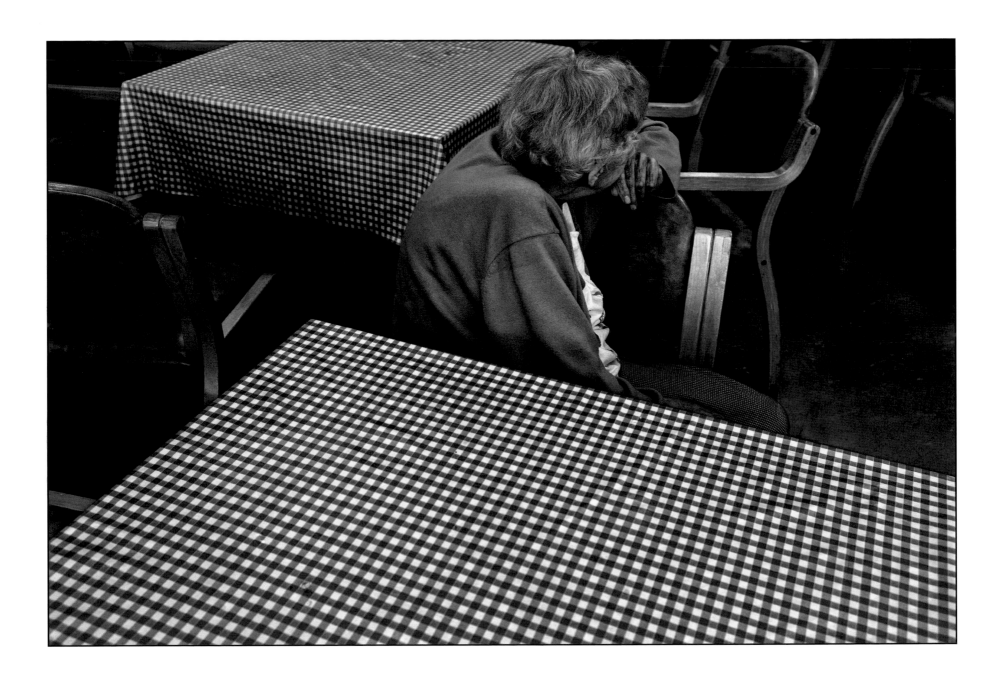

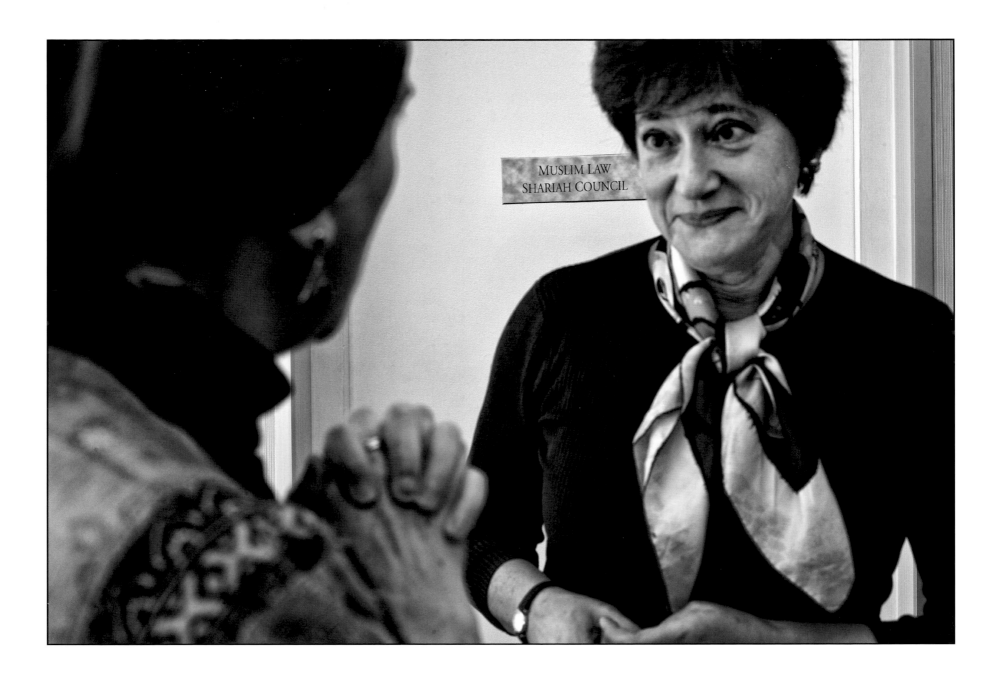

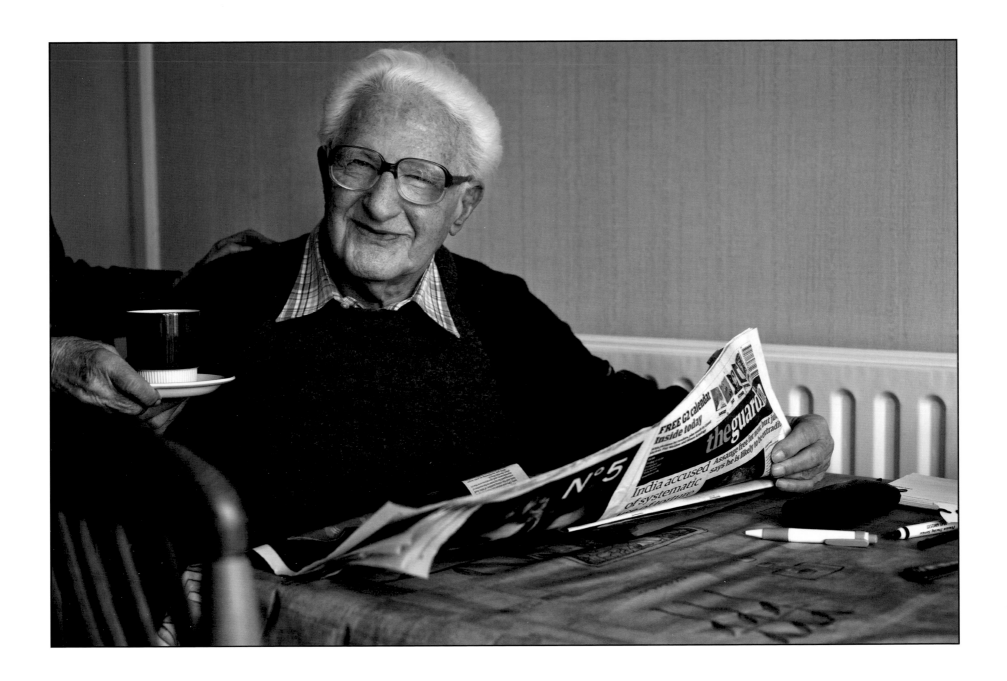

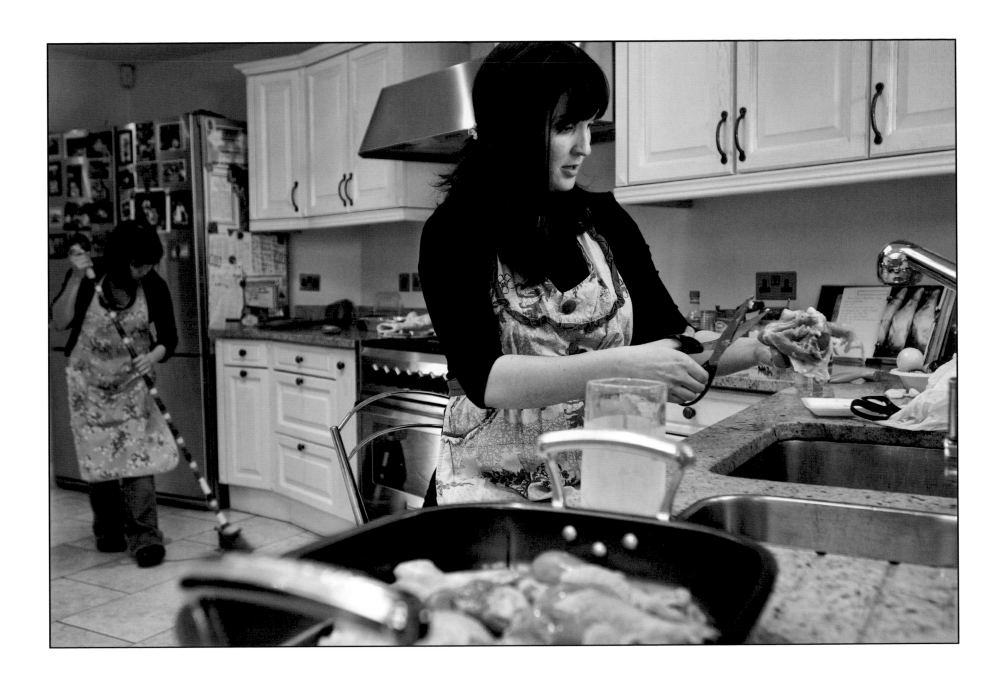

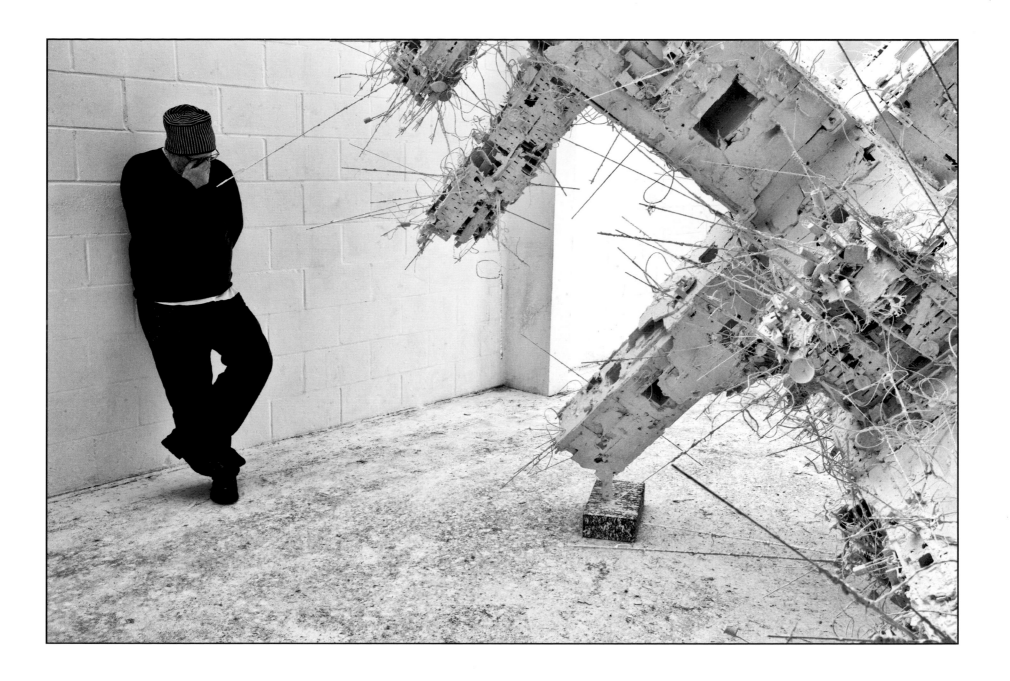

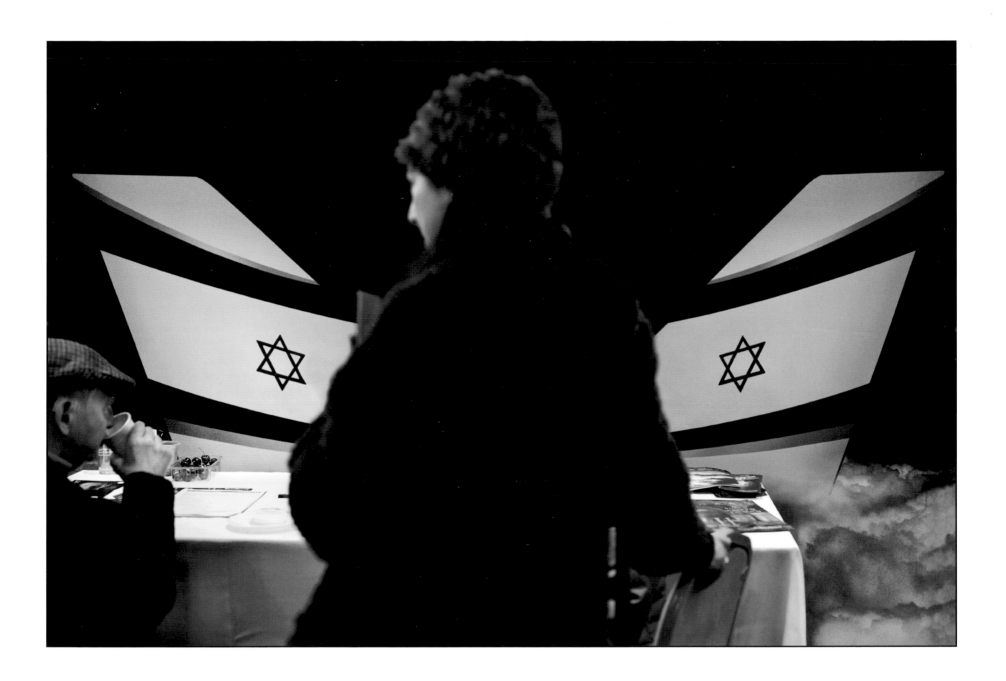

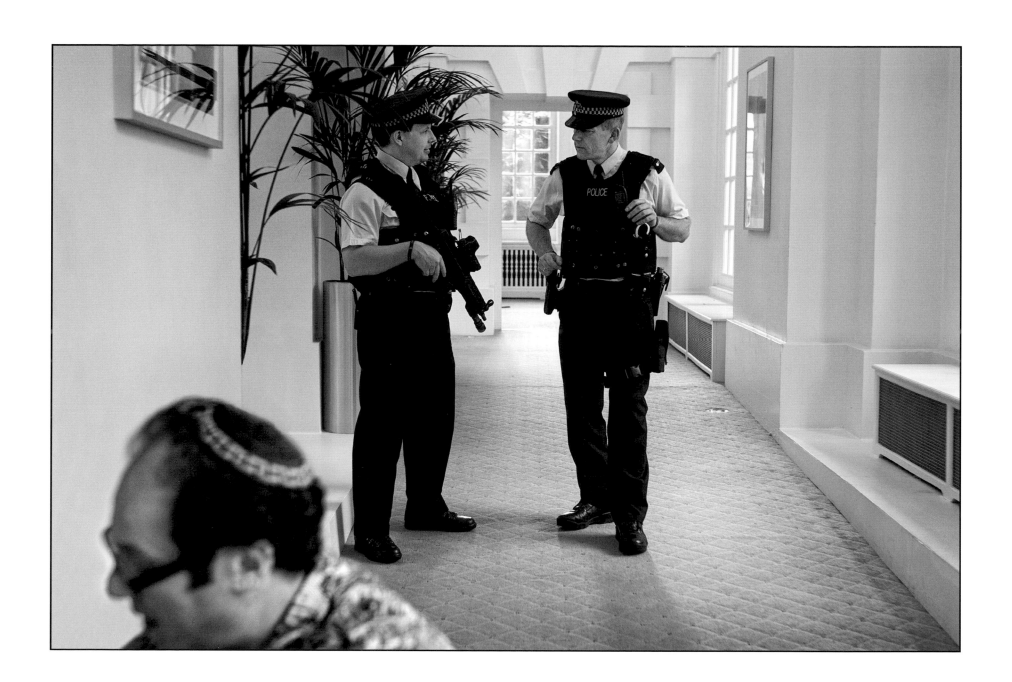

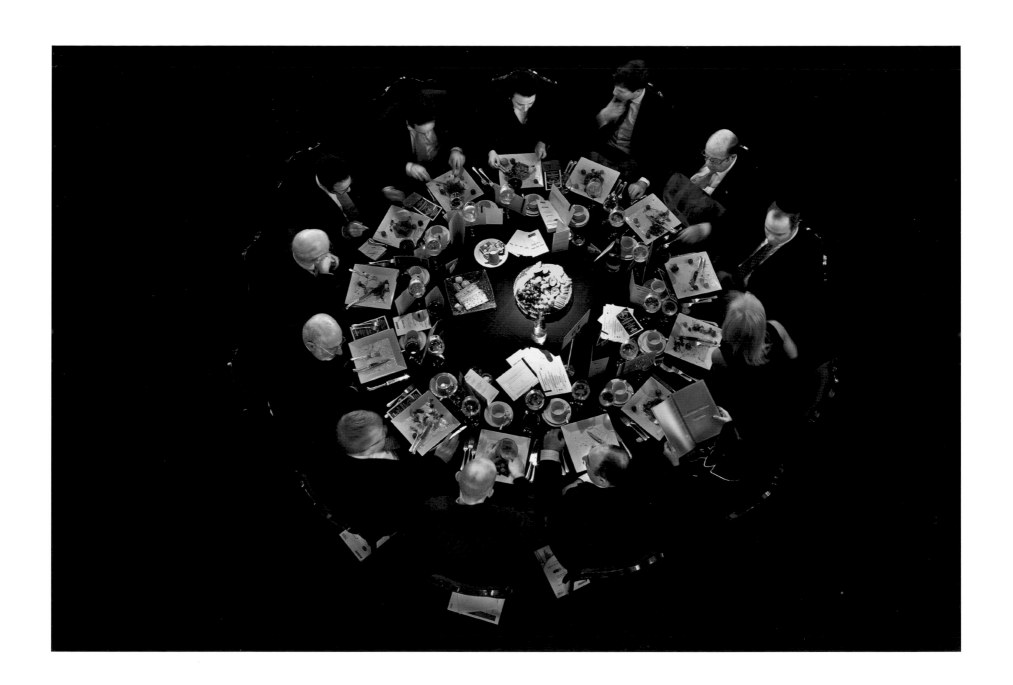

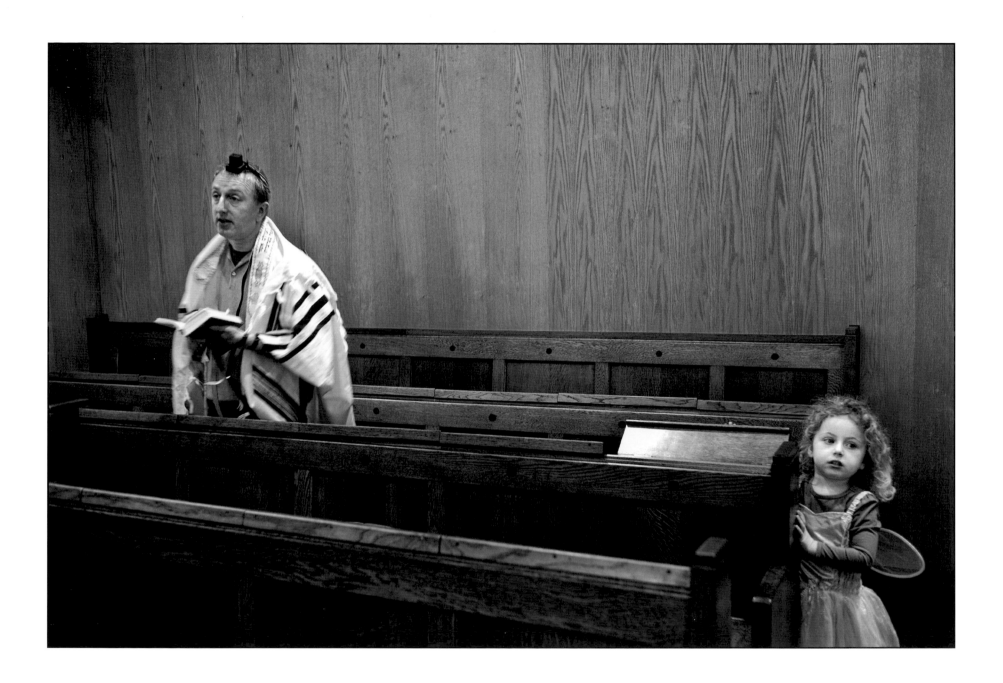

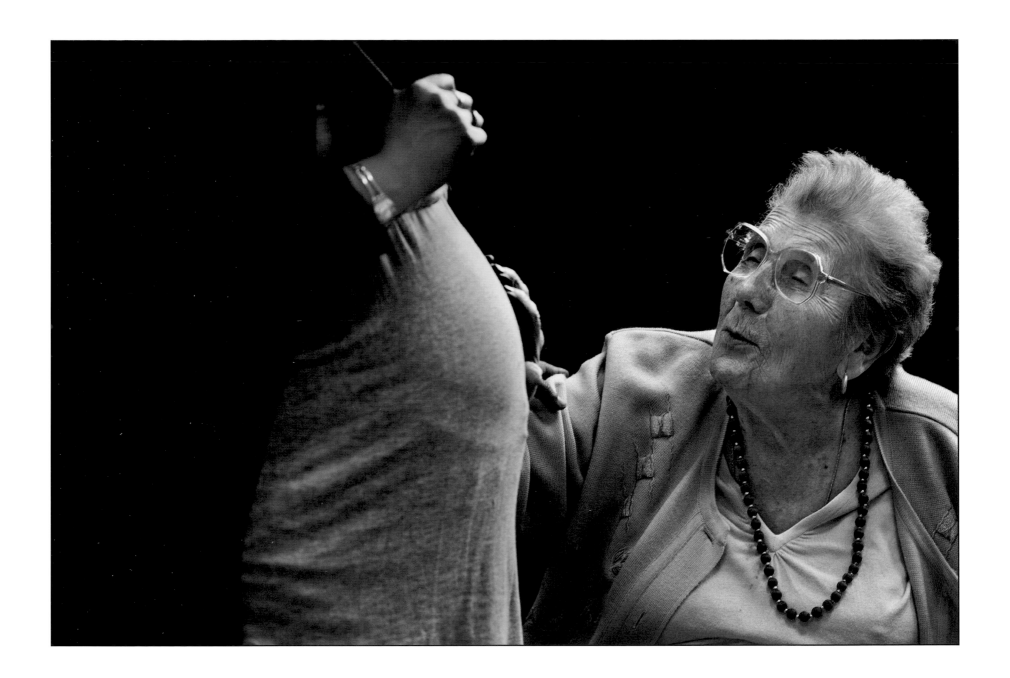

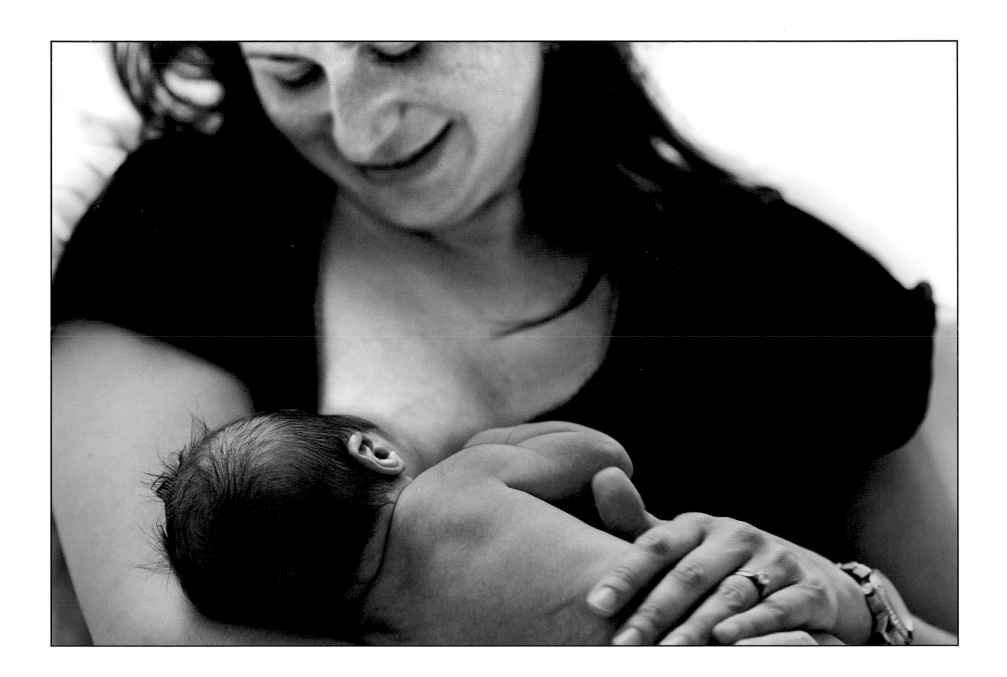

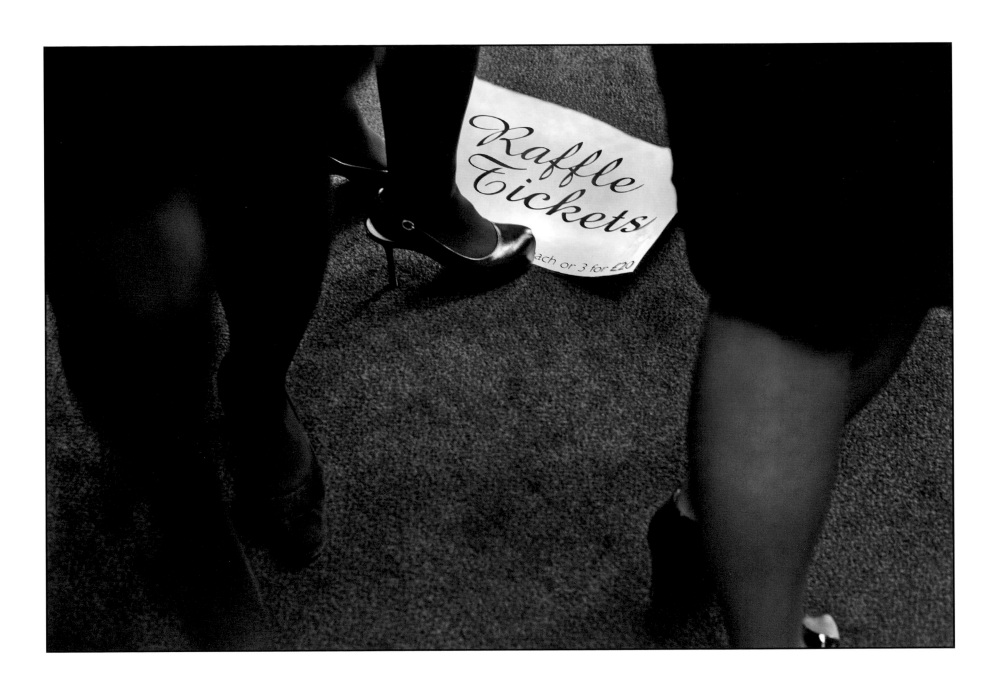

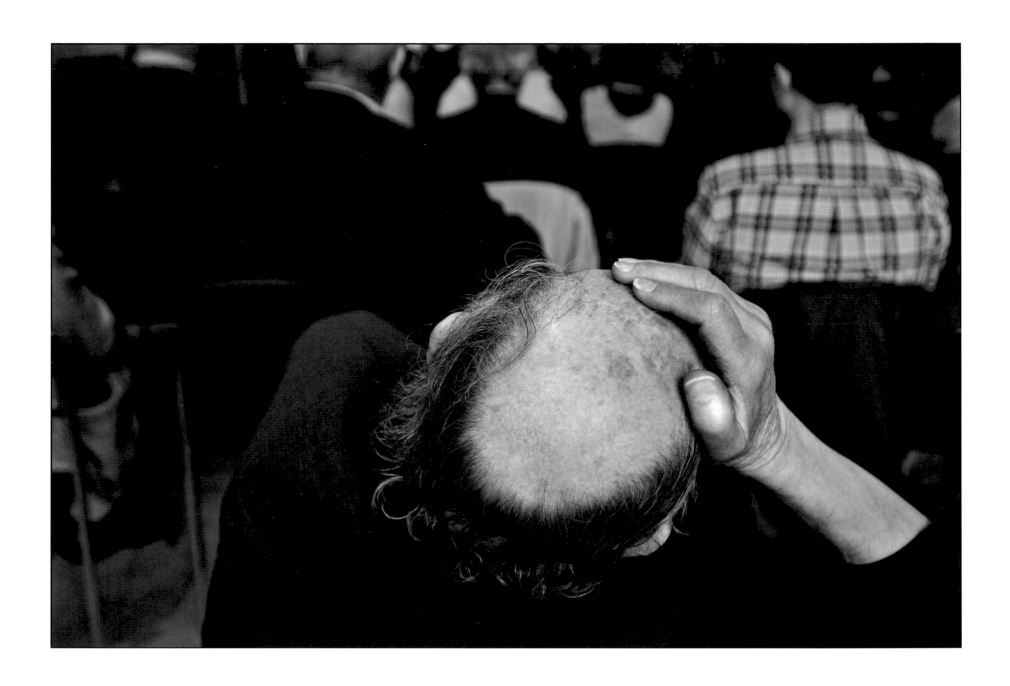

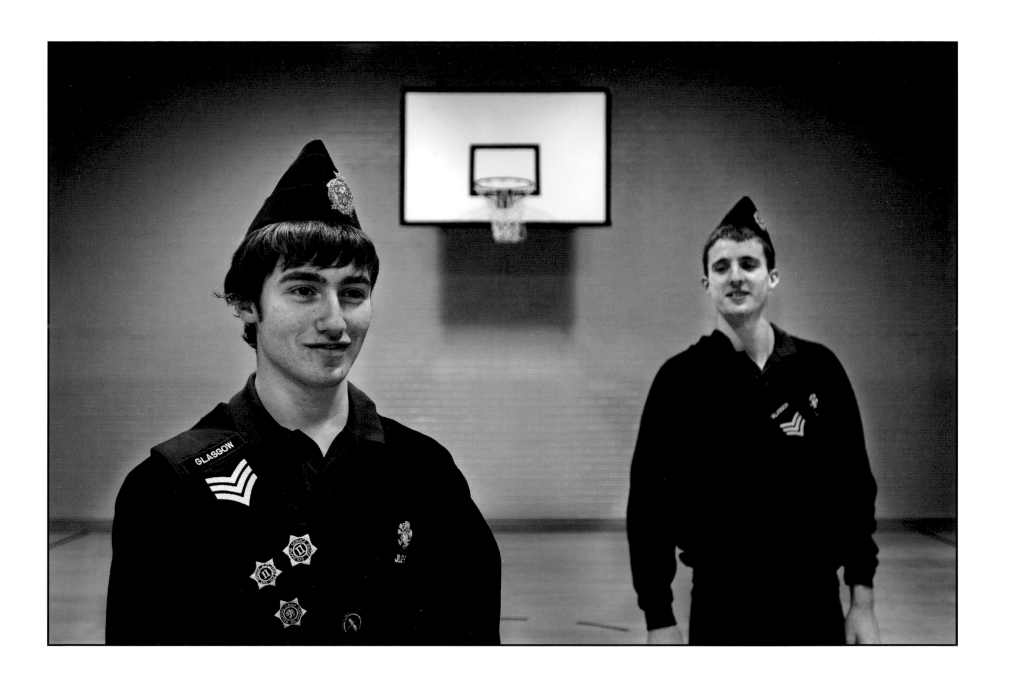

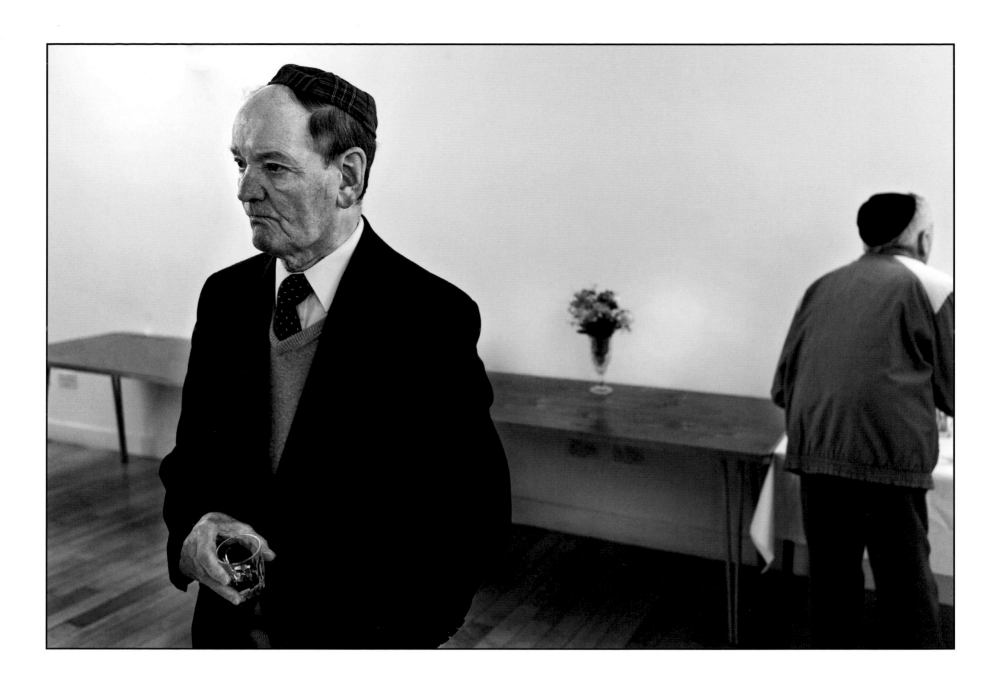

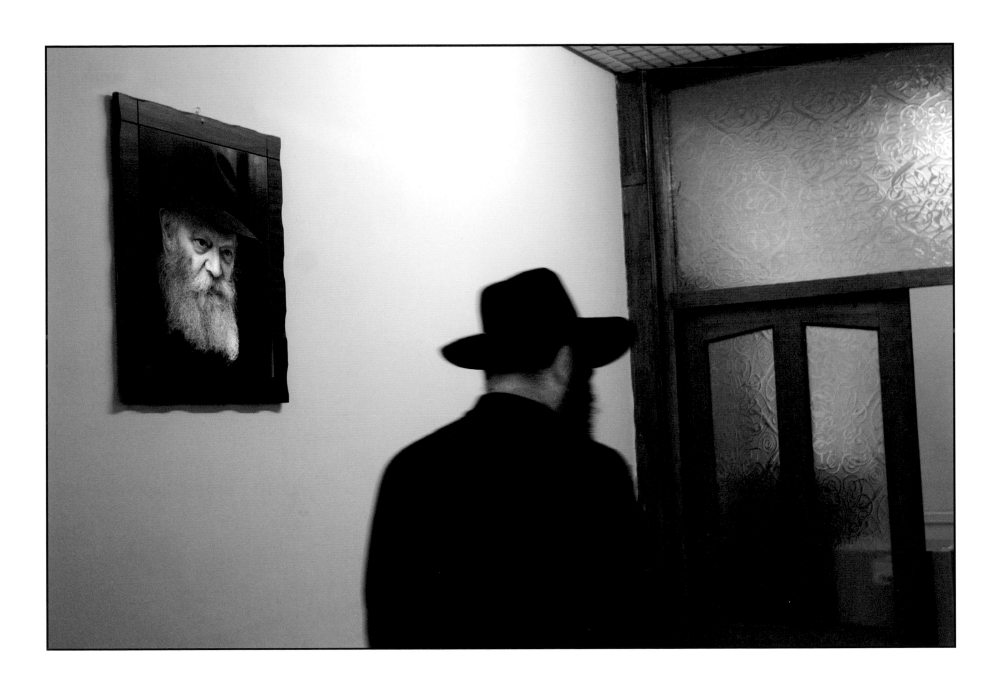

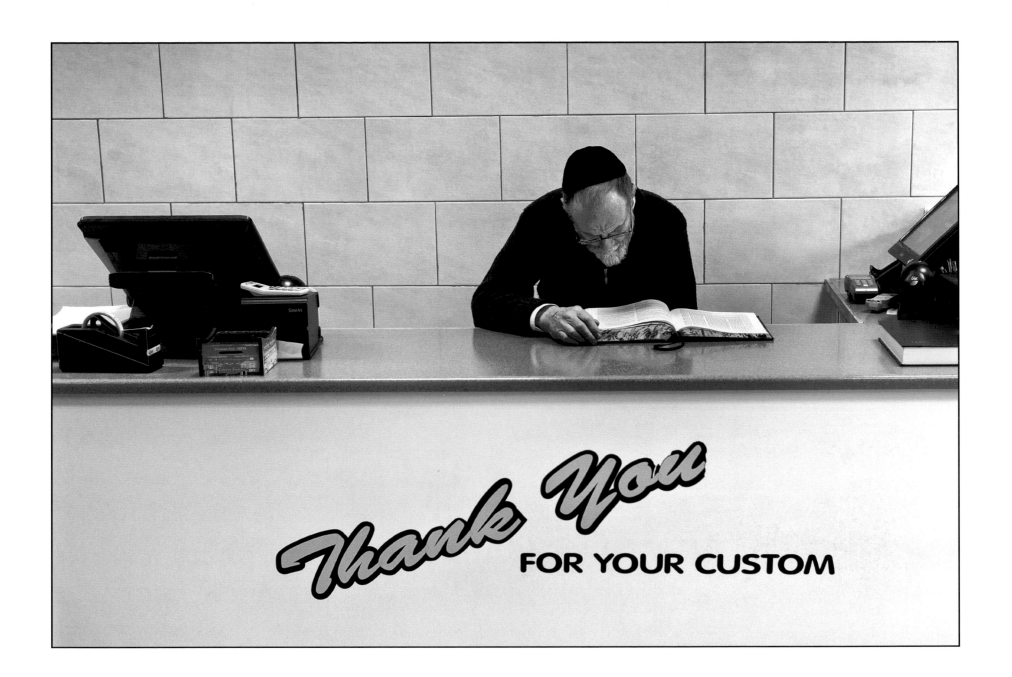

BIRMINGHAM 2010 Tree of Life memorial to relatives of members of the Progressive synagogue congregation. p 13

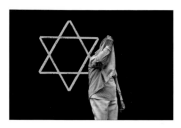

SOUTHEND 2010 Entrance to the Orthodox synagogue. p 15

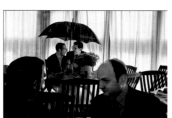

LONDON 2010 A *Sukkah* for bankers, lawyers and stockbrokers at Canary Wharf. p 17

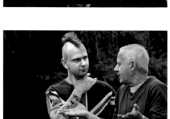

LONDON 2009 Klezmer Fest, Regent's Park. p 19

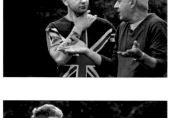

LONDON 2009 Klezmer Fest, Regent's Park. p 21

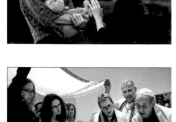

LONDON 2010 *Simchat Torah* at a Liberal congregation in West London, whose members are redefining contemporary Jewish life through the open and active involvement of gay men and women, feminists, couples from mixed religious backgrounds and those who don't regard themselves as religious. p 23

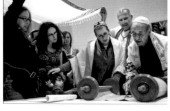

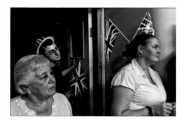

LONDON 2010 Singing *Rule Britannia* at the end of a variety show in an East End day centre for the elderly. p 25

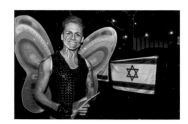

LONDON 2009 Late night party in the East End to mark the launch of EasyJet's route to Tel Aviv. p 27

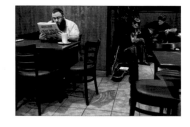

MANCHESTER 2010 Coffee shop in the Orthodox Broughton Park neighbourhood. p 29

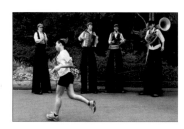

LONDON 2010 Klezmer Fest, Regent's Park. p 31

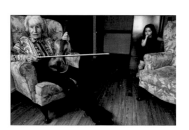

BRIGHTON 2010 A former concert violinist at an elderly care home. p 33

LONDON 2010 Saturday morning religion class at a Liberal synagogue. p 35

BRIGHTON 2010 Reading room at an elderly care home. p 37

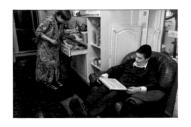
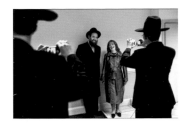
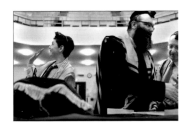
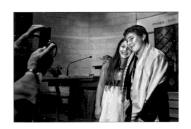
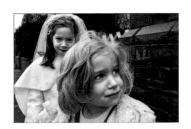
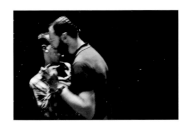
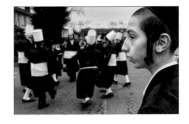
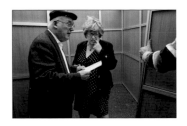
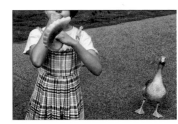
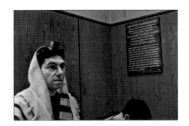
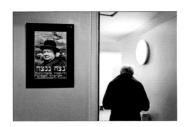
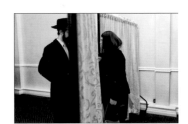
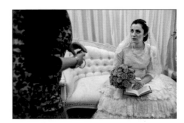
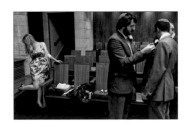

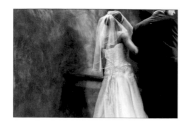 **LONDON 2010** The bride and her father wait for the signal to make their entrance at a Liberal synagogue. **p 67**

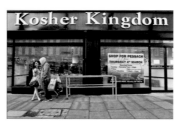 **LONDON 2010** Shopping for *Passover* in Golders Green. **p 81**

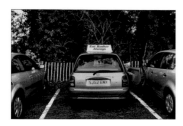 **GLASGOW 2010** Synagogue car park. **p 69**

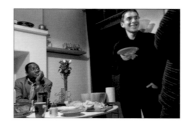 **LONDON 2009** A refugee from Darfur at Moishe House, an urban commune in north London, whose social action programme provides refugees with advice and assistance on welfare issues. **p 83**

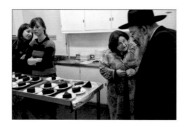 **GATESHEAD 2011** A rabbi has a word with the catering manager in the kitchen of an Orthodox synagogue during a dinner celebrating a *Bar Mitzvah*. **p 71**

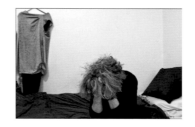 **LONDON 2011** A woman in her room at a Jewish Women's Aid shelter for victims of domestic violence. **p 85**

 LONDON 2011 Dinner time in a *Haredi* home in the Orthodox neighbourhood of Stamford Hill. **p 73**

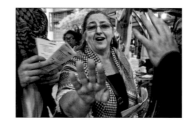 **LONDON 2009** A demonstrator from the Palestine Solidarity Campaign protests the launch of EasyJet's route to Tel Aviv. **p 87**

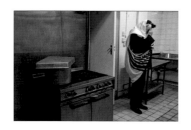 **BIRMINGHAM 2010** A *Mashgiach* pauses for morning prayers during his inspection of a kosher deli. **p 75**

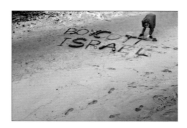 **LONDON 2009** A demonstrator from the Palestine Solidarity Campaign protests the launch of EasyJet's route to Tel Aviv. **p 89**

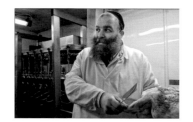 **LUTON 2010** A *Shochet* working in an abattoir prepares to slaughter a chicken according to the laws of *Kashrut*. **p 77**

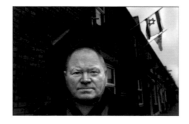 **BELFAST 2011** A member of the Ulster Volunteer Force on a street in Protestant East Belfast, where Loyalist residents fly the Israeli flag to show their support for the Jewish state. This is widely seen as a response to the practise in Catholic West Belfast, where Republicans display the Palestinian flag in support of Palestinian independence. **p 91**

218

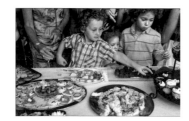 **LONDON 2010** *Kiddush* following Sabbath morning prayers at a Liberal synagogue. **p 79**

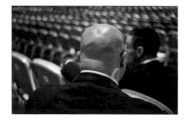 **LONDON 2009** A Community Security Trust (CST) officer conducts a security sweep before a performance by an Israeli singer at a West End hotel. **p 93**

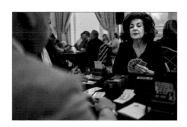

LONDON 2010 Charity fund-raising bridge tournament at a West End hotel. **p 95**

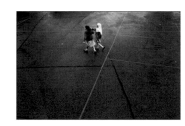

BIRMINGHAM 2010 King David Primary School. **p 109**

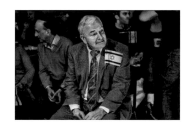

LONDON 2010 Israel independence day celebration organised by the Zionist Federation. **p 97**

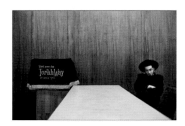

MANCHESTER 2010 Morning study session at an Orthodox synagogue. **p 111**

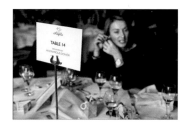

LONDON 2010 Women's fund-raising charity brunch at a hotel in Canary Wharf. **p 99**

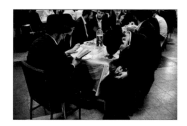

MANCHESTER 2010 *Yeshiva* students at lunchtime reciting *Birkat Hamazon*, the traditional blessing after a meal. **p 113**

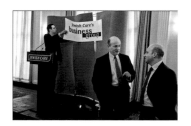

LONDON 2010 Charity fund-raising breakfast at a West End hotel. **p 101**

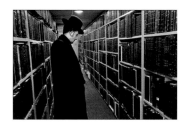

GATESHEAD 2011 A *yeshiva* student browsing in a book store specialising in religious tracts required for his study. The books are almost exclusively in Hebrew or Yiddish. **p 115**

LONDON 2010 Reception committee waiting in a Canary Wharf hotel lobby to welcome guests arriving for a charity fund-raising brunch. **p 103**

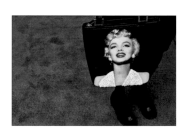

LONDON 2009 A woman attending a *Simcha* planning fair at an Orthodox synagogue. **p 117**

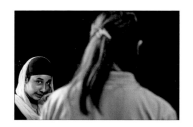

LONDON 2010 Muslim and Jewish sixth form college students meeting at an inter-faith workshop. **p 105**

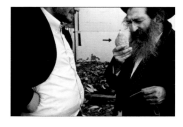

LONDON 2010 A rabbi inspecting an *etrog* for any imperfections which may disqualify it from use during *Sukkot* according to Orthodox ritual law. **p 119**

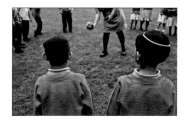

BIRMINGHAM 2010 King David Primary School. While the school has an Orthodox Jewish religious curriculum, its population is 55% Muslim, 25% Christian, Hindu, Sikh and Buddhist, and 20% Jewish. **p 107**

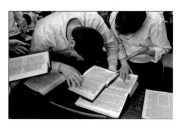

GATESHEAD 2011 *Yeshiva* students studying the *Talmud*. **p 121**

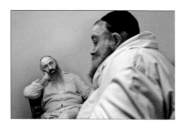

LUTON 2011 Two *shochtim* taking a break from their work at an abattoir. **p 123**

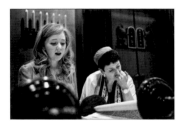

SOLIHULL 2010 Afternoon barbeque at an Orthodox synagogue. **p 125**

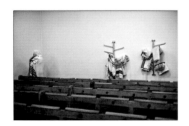

LONDON 2010 *Bar Mitzvah* rehearsal at a Reform synagogue. **p 127**

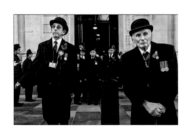

GLASGOW 2010 A man praying at an Orthodox synagogue. **p 129**

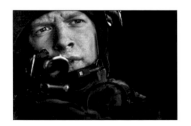

LONDON 2009 Annual parade of the Association of Jewish Ex-Servicemen (AJEX) at Whitehall. **p 131**

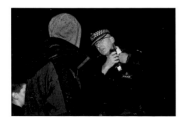

DALBEATTIE 2011 An officer cadet at the Royal Military Academy, Sandhurst, on his final training exercise before joining his regiment as a Second Lieutenant and being deployed as a platoon commander in Afghanistan. **p 133**

LIVERPOOL 2011 A police officer in charge of a youth offenders unit questions two boys on the street about a robbery he's been called out to investigate. **p 135**

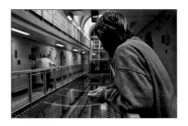

LONDON 2010 An inmate at Wandsworth Prison. **p 137**

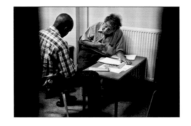

BELFAST 2011 Inside the wall of Crumlin Road prison. Somewhere along this stretch of ground, along with 16 other men executed and buried in unmarked graves, lie the remains of the only Jew to have been hanged in Great Britain. Itinerant circus worker Eddie Cullens was 28 years old when he was convicted of murdering a fellow worker and hanged in 1932. **p 139**

LONDON 2010 A doctor advises an asylum seeker at a drop-in centre for African refugees run by members of a *Masorti* congregation. **p 141**

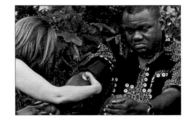

LONDON 2010 A doctor examines an asylum seeker at a drop-in centre for African refugees run by members of a *Masorti* congregation. **p 143**

BELFAST 2011 A school boy on a class visit to an Orthodox synagogue. **p 145**

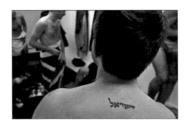

CHESHUNT 2010 Maccabi Lions football team changing room after a game. **p 147**

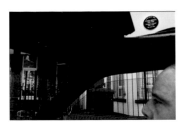

BELFAST 2011 Plaque outside the birthplace of Haim Hertzog, Israel's sixth president. **p 149**

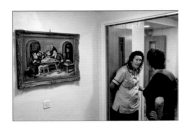

SOUTHEND 2010 Members of a London day centre for the elderly visiting the seaside in Southend. **p 151**

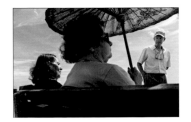

BRIGHTON 2010 A nurse at an elderly care home with a relative of one of the residents. **p 153**

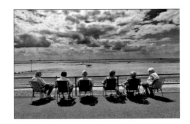

SOUTHEND 2010 Retirement by the seaside. **p 155**

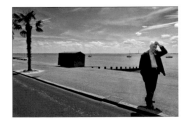

SOUTHEND 2010 A member of a London day centre for the elderly visiting the seaside in Southend. **p 157**

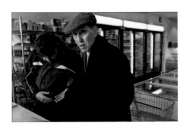

GLASGOW 2010 Inside the only Kosher deli in Scotland. **p 159**

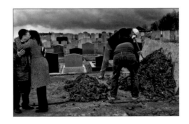

GLASGOW 2010 Mourners at an Orthodox funeral at Glenduffhill cemetery. **p 161**

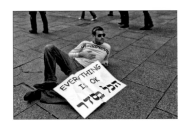

LONDON 2009 Street performance in Leicester Square. **p 163**

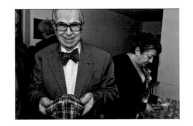

LONDON 2010 Inauguration ceremony for the Lord Mayor of London. **p 165**

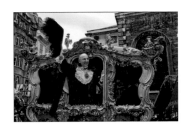

GLASGOW 2011 Burns night at the Reform synagogue. **p 167**

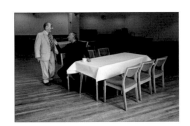

LONDON 2010 Saturday morning, before the start of *Shabbat* services, at a Liberal synagogue. **p 169**

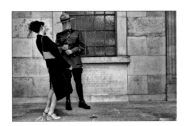

LONDON 2010 Guests arriving for a wedding at a Liberal synagogue. **p 171**

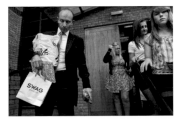

BIRMINGHAM 2010 The father of a *Bat Mitzvah* girl leaving the Reform synagogue with his daughter's gifts and her friends. **p 173**

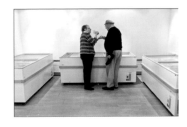

GLASGOW 2010 The frozen food section of the only Kosher deli in Scotland. **p 175**

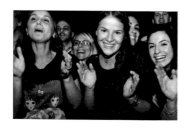

LONDON 2009 Concert for an Israeli singer in the West End. p 177

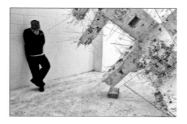

LONDON 2010 Artist in his North London studio. His sculpture – The Crusader – is a commission by the Imperial War Museum North in Manchester, where the piece is now installed. p 191

WARWICK 2010 A participant at Limmud, the annual conference for Jewish learning and culture, Warwick University. p 179

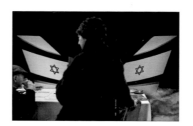

LONDON 2010 Israel Expo, an annual event designed to encourage *aliya* (immigration) to Israel. p 193

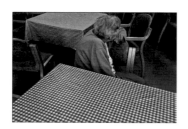

LONDON 2010 Day care centre for the elderly in the East End. p 181

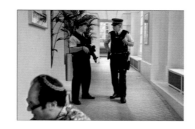

LONDON 2009 Security at a Board of Deputies meeting. p 195

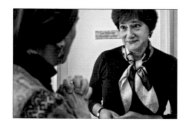

LONDON 2010 A Reform rabbi (right) and a Muslim woman talking at an interfaith seminar where Jews and Muslims meet to discuss readings from the Torah and the Qur'an. p 183

LONDON 2010 An annual charity fund-raising dinner. The £1500-a-couple dinner ticket is the basic building block of Jewish philanthropy. p 197

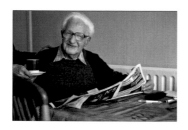

LONDON 2010 A Holocaust survivor and retired physiotherapist in his home in North London. p 185

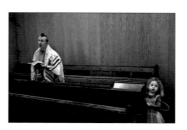

LONDON 2010 Sunday morning *minyan* at an Orthodox synagogue. p 199

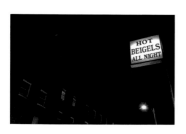

LONDON 2010 Bagel bakery on Brick Lane. p 187

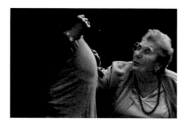

LONDON 2010 A regular visitor to an East London day centre saying goodbye to one of the care workers who is starting her maternity leave. p 201

222

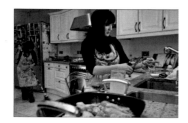

LONDON 2011 An Orthodox woman prepares the traditional Friday night dinner in the kitchen of her North London home. p 189

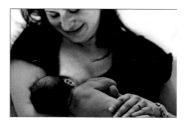

LONDON 2011 Devorah Rachel Taylor – 37 minutes old. p 203

 LONDON 2010 Charity fundraising brunch at a hotel in Canary Wharf. p 205

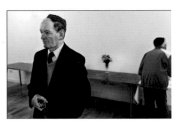 **GLASGOW 2010** *Kiddush* following the Saturday morning service at the Reform synagogue. p 211

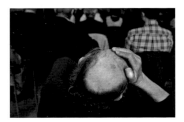 **LONDON 2009** Board of Deputies meeting. p 207

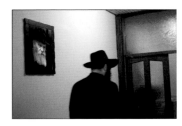 **MANCHESTER 2010** The Lubavitch *yeshiva* in the city's Salford neighbourhood. p 213

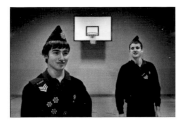 **GLASGOW 2010** Weekly meeting of the Jewish Lads and Girls Brigade. p 209

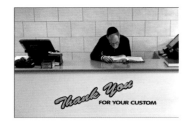 **GATESHEAD 2011** The owner of a kosher butcher shop studying his *Talmud* between taking orders. p 215

acknowledgements

Trevor Pears' belief that photography can be a powerful agent of social change is what made *No Place Like Home* possible. He and Amy Braier, Charles Keidan and Carolyn Rozenberg at Pears Foundation have supported this project with generosity and enthusiasm from its inception.

In addition, many people all around the country helped in a variety of invaluable ways, giving of their time, their expertise, their contacts, their opinions and their hospitality. I am grateful to all of them for their kindness.

Mike Abrahams
Wilna Ackerman
Max Adleman
Sara Barnett
Emma Bell
Luciana Berger
Charles Berry-Ottaway
Rev. Michael Binstock
Rickie Burman
Atalia Cadranel
Adrian Cohen
Mark Cohen
Adele and Michael Conn
Nicola Cutts

Geraldine D'Amico
Marion Davis
Louise Ellman
Rabbi Herschel Gluck
Ellen Goldberg
Rabbi Mark Goldsmith
Mike Goldwater
Linda Grant
Michele Grant
Jerry Harris
Justine Harris
Sara Hoshen
Joanna Hyman
Rabbi Margaret Jacobi

Rabbi Laura Janner-Klausner
Gerry Judah
Lazer Kahan
Dorne Kanareck
Deborah Koder
David Knopov
Eve Kugler
Carol Laser
Ben Morrison
Carmella Myer
Martin Newman
Frankie Quinn
Katy Radford
Rabbi Judith Rosen-Berry

Shiri Shalmi
Sara Shalom
Rabbi Sybil Sheridan
Rabbi Sheila Shulman
Adam Solomons
Ita Symons
Fiona and Richard Taylor
Anne Weber
Daniel Weil
Hannah Weisfeld
Jacques Weisse
Irene Wise
Rabbi Alexandra Wright

First published in Great Britain 2013

All Photography and editorial material copyright © Judah Passow, 2013

Introduction © Jonathan Freedland, 2013

The moral right of the author has been asserted

A Continuum book

Bloomsbury Publishing Plc
50 Bedford Square
London WC1B 3DP

www.bloomsbury.com

Bloomsbury Publishing, London, New Delhi, New York and Sydney

Published with the kind support of Pears Foundation and in association with the Jewish Museum

www.pearsfoundation.org.uk
www.jewishmuseum.org.uk

A CIP record for this book is available from the British Library.

ISBN 978-1-4081-9316-7

10 9 8 7 6 5 4 3 2 1

Design by James Watson

Printed and bound by Arti Grafiche Amilcare Pizzi. Italy.